Painting Without Paint

Landscapes with your tablet

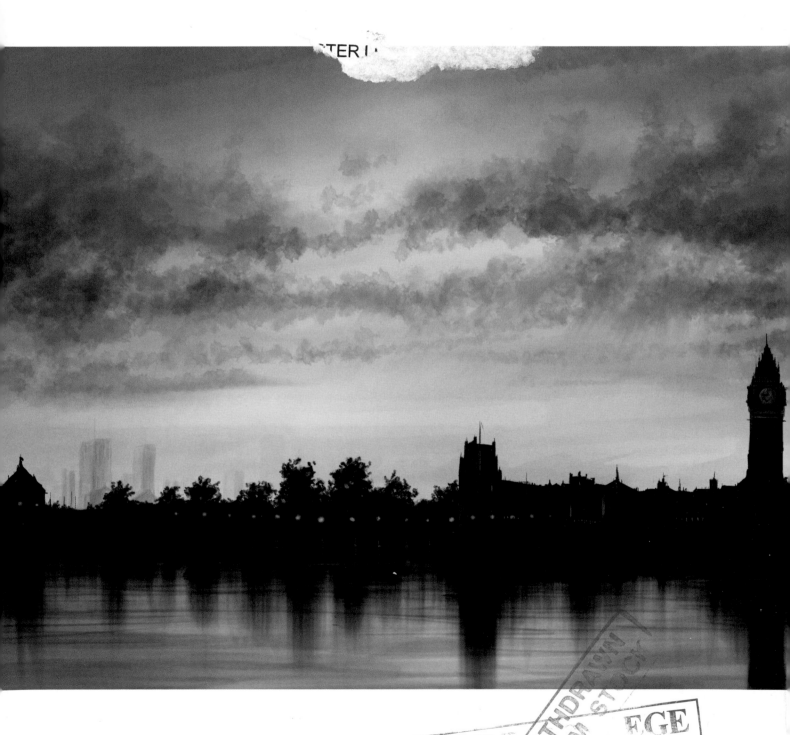

Dedication

To Sarah, for coming into my life and making me and everyone around her happy.

Also to my Mum, whose continued support and encouragement is essential.

Finally to my Dad, Ken Palmer (1938–2015), may he rest in peace and keep sailing on.

Painting Without Paint

Landscapes with your tablet

Matthew Palmer

SEARCH PRESS

First published in 2016

Search Press Limited
Wellwood, North Farm Road,
Tunbridge Wells, Kent TN2 3DR

ISBN: 978-1-78221-284-3

ebook ISBN: 978-1-78126-313-6

Suppliers
If you have difficulty in obtaining
any of the materials and equipment
mentioned in this book, then please
visit the Search Press website for
details of suppliers:
www.searchpress.com

You are invited to visit the author's
website for digital and
watercolour art tutorials:
www.watercolour.tv

Printed in China

Acknowledgements

A big thank you to Jean and Richard and all at the Society
for All Artists for their help and continued support.

Thank you to Katie and Edd and all at Search Press for all
the help and support on this project.

Thanks to my parents for believing in me and the
encouragement they gave; and finally to Sarah for being
my world.

Page 1
Atmospheric London Sunset
*The skyline across the River Thames in London is such an iconic silhouette,
and one of my favourite views in the UK. This and the painting opposite
were painted in the Procreate painting app.*

Opposite:
Across the Valley
*A picturesque church pictured during a warm summer's evening as the
night draws in.*

Contents

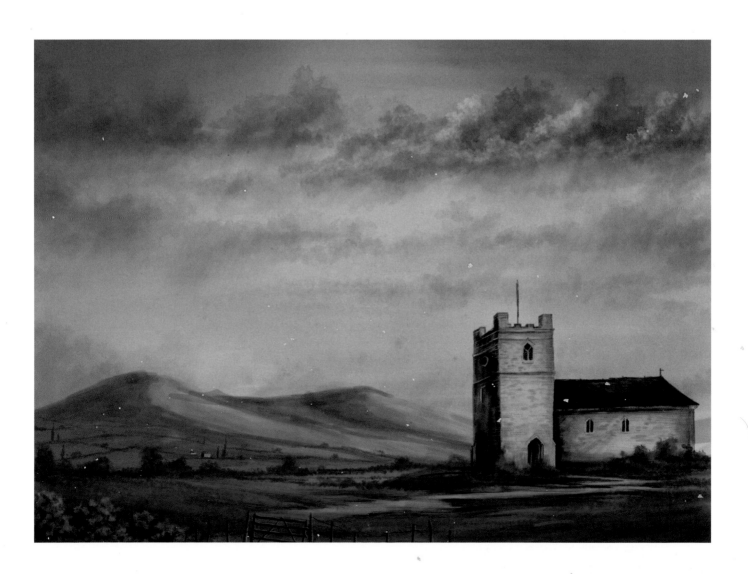

Introduction

As an established professional artist and tutor for twenty years, I enjoy using all forms of painting media. I also love sketching and painting when out and about. The digital medium makes this really easy and, since you need only your tablet and a finger, it is an 'always with me' art form.

The feel of painting on the tablet screen is surprising similar to traditional painting, and if you use a brush stylus, it is even closer. In fact, I apply the same approach to my digital painting as I do to my acrylic and watercolour painting.

Apart from the obvious advantages that no water or paints are needed, all the same principles apply to digital art as to traditional art. You can even work in layers as you do in watercolour; for example, the sky on the first layer, the distant background mountains overlaid on a second layer, and layer three is the foreground. The big advantage of digital art is that you can alter each layer at any point – even transform it entirely. If you start to feel a background mountain is too large, for example, you can change the colour, resize it, or remove it entirely. Perhaps you have just painted a seascape and a yacht but later decide you want another yacht – digital art allows you not only to duplicate the yacht but also to alter its size, position and colour.

Just like different painting media, different painting applications or 'apps' work differently, and they all have their own pros and cons. In addition, new apps are developed and new features are added to existing ones. It is an exciting time to dip your toes into digital art!

I find tablet art addictive; you can be sitting on the train or in the pub and produce a painting using no water, no paint and creating no mess – it's great. I would encourage anyone to give it a go; once you start you will find you just can't stop. Painting without paint is its own art form.

Venice

As shown in the work-in-progress pictures above, I paint with my tablet exactly as I do with paint on canvas or paper: starting with a sky, I add the midground before working forward towards the foreground. The finished painting opposite, created on Procreate, shows the results you can get with this wonderful digital medium.

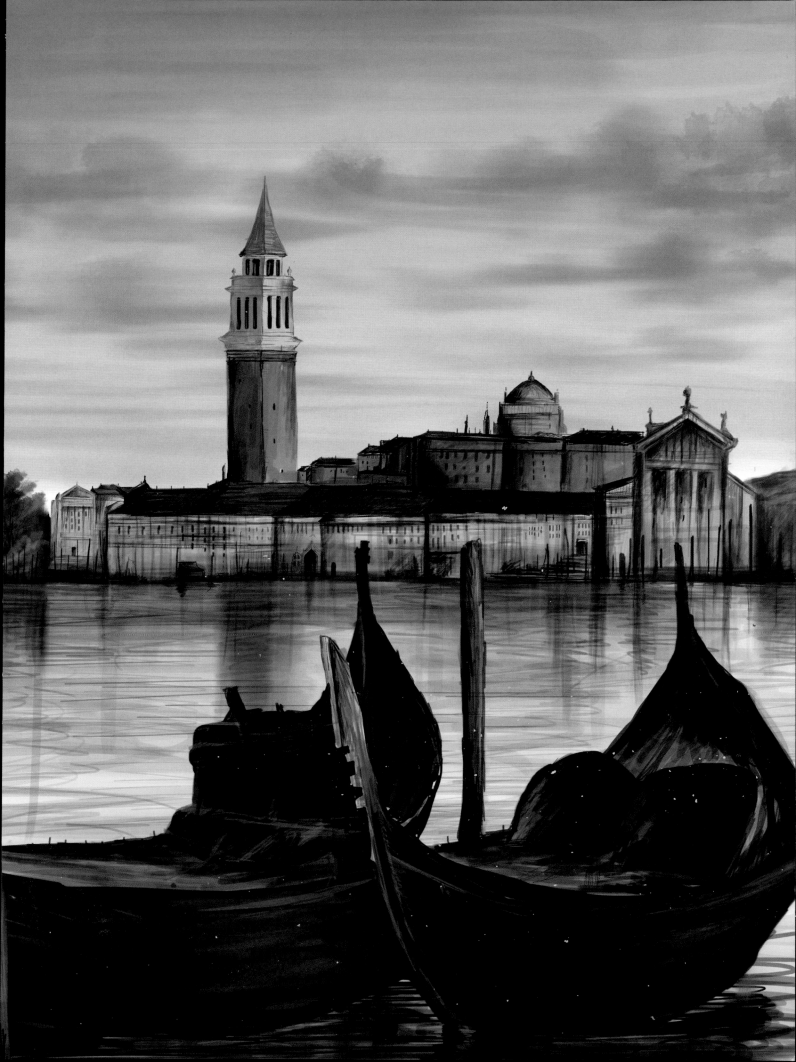

Materials

You need very little to begin digital painting – just a tablet computer and your finger, and away you go. The following pages look in more detail at what is available to you.

Tablet

One of the first questions my students ask me is 'Does it matter which tablet I use?' The short answer is no. There are lots of different tablet types, but most use either the iOS or Android operating systems. Whether you choose an Android or iOS-based tablet does not really matter. Although I focus on the iPad in this book, from time to time I use an Android tablet to paint with. New software and apps are being developed all the time for both of the popular tablets types. As long as your tablet has a touchscreen and the ability to download a painting app, you will be able to use it.

That said, the iPad has a much greater choice of apps or 'applications' for art. This is simply because iPads are much more popular then other tablets so developers create more content for this device. However, similar art apps are available for, and some are even unique to, the Android platform. The great thing is that once you have learned one application, they are all fairly similar.

A selection of digital tablets and smartphones.

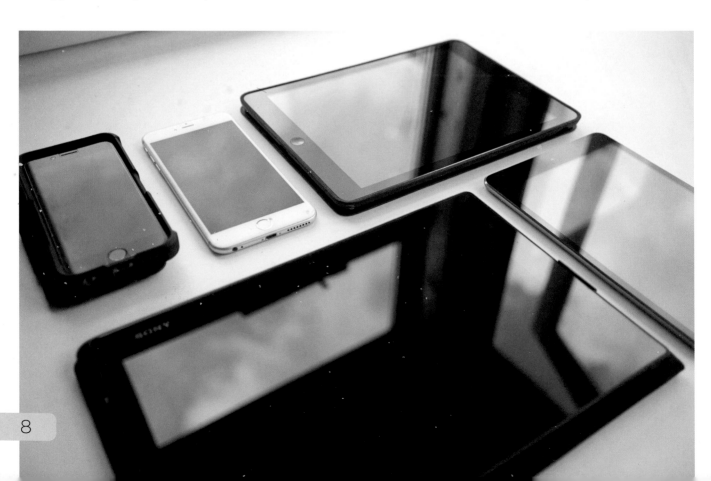

MATTHEW'S MATERIALS – MY PREFERRED TABLET

I use an iPad Pro, an iPad Air and an iPad Mini, which have 33cm (13in), 25.5cm (10in) and 20cm (8in) screen sizes respectively. All work well and the one I choose to use depends simply on which one I have with me at the time. I have even used my iPhone to produce a painting, as the same apps are available for smartphones as well.

New tablets and updated models of existing tablets come onto the market each year, with various sizes of screen. The great news is that all models are perfectly fine to paint with. Although you might think working on a smaller screen size is more difficult, I do not really feel there is much difference, as you soon get 'in the zone'.

Whatever you choose to use, it is important to note that brush sizes will vary depending on your tablet. A 100px brush on an iPad Air, for example, will be equivalent to a 150px brush on an iPad Mini, owing to the smaller screen size.

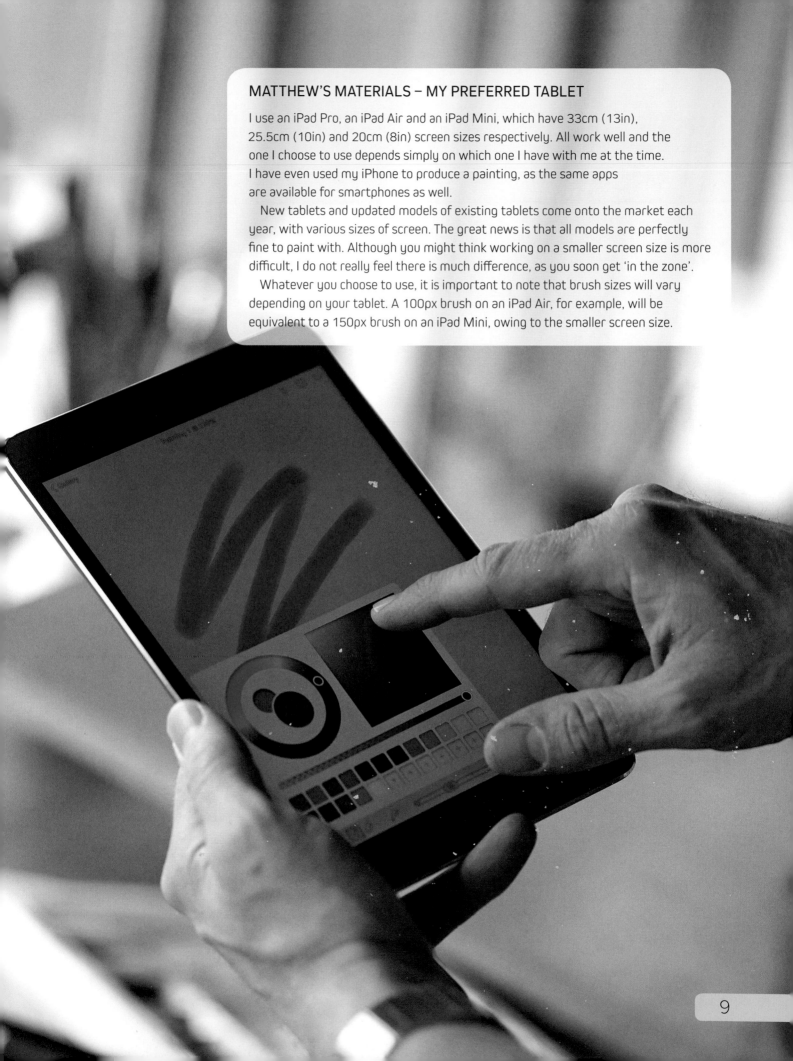

Brushes Redux

Procreate

SketchBookX

ArtRage

Art Set

*Just a few of the many
art apps available today.*

Apps

'App', short for application, is another name for a computer program or
software. When people talk about apps they are normally referring to
programs that run on mobile devices like iPads and Android tablets.
A tablet is nothing without the apps.

There are over 1.5 million apps for download on iOS and more than
750,000 for Android or other tablet devices. A huge proportion of these
apps are games and utility programs but there is also a huge variety
of creative apps, including art apps. These vary from photography to
design, from sketchbook apps to the painting programs we look at here.
New apps are introduced all the time. The great thing about art apps is
that they tend to use similar sets of tools, colour palettes and brushes,
so once you have learned how to use one, you will be able to find your
way around them all.

How do I download apps?

When you buy a tablet computer, it will have a built-in app store or play store. These are the areas you go to in order to buy and download apps. Some apps are free and others you pay for. Try looking up 'art apps' on your internet search engine to find out more on specific apps.

Are all apps similar?

It is important to say that while each of the apps is unique, they all share similarities. For example, they all use varied styles of brushes, they all allow you to increase the brush size, choose various colours and work with layers. My recommendation is to stick with one app to begin with and learn to use that.

Once you feel confident, start playing around with other apps. A particular app might have a special feature that you love and only playing around or experimenting with the program will bring this out.

Do art apps change over time?

A great thing about apps is that they get updated for free. In these updates, the programmers fix bugs and include new features, but the basic structure of the app will stay the same. Updates normally add minor improvements, so even in several years' time the app will probably be recognisable. As a result, the techniques in this book will always be relevant and work with all painting and art apps.

Which painting app is best?

I have been painting with an iPad for several years and a few apps stand out to me as my favourites. These are *Brushes* (the current version is called *Brushes Redux*), *Procreate* and *ArtRage*. The instructions in this book are demonstrated on the *Brushes* app, because it is versatile and free, but the information can be applied more generally to other apps. There are notes throughout to give pointers on using other apps, particularly *Procreate*.

MATTHEW'S MATERIALS – MY PREFERRED APPS

Here are my favourite apps for tablet painting. The digital world moves quickly, so while the information presented here, including the prices, is correct at time of going to press, it may be that things are slightly different when you read this. Don't panic – as I mentioned earlier, app updates tend to be fairly minor, so the information will remain largely correct.

Tip

A good exercise is to doodle! Make a mess on a blank canvas to learn what your app can do.

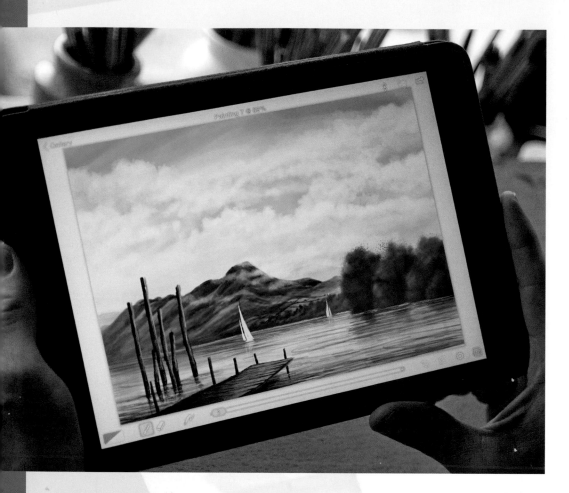

BRUSHES

Price: free

Brushes, also called *Brushes Redux*, is probably the best-known tablet art app and the one I use most of the time. It has everything you need, including layers, editable brushes and masses of colour choice. It is a great all-round art app, and my personal favourite. For these reasons the majority of tutorials in this book will be on *Brushes*.

PROS: A free program, very easy to use, with nice export options. It records a video of your artwork for playback, has lots of colour choice and fully editable brushes.

CONS: Limited in the number of layers, no smudge or blend tool, and it is only available for iOS devices.

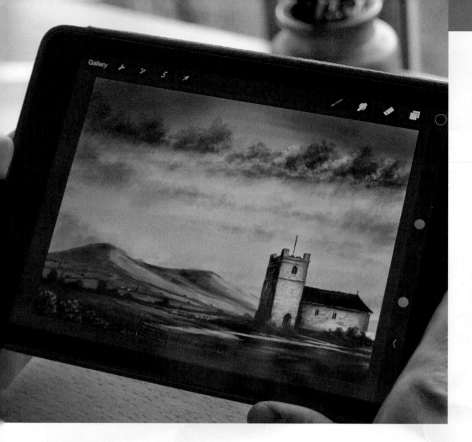

PROCREATE

Price: £4.49 ($4.99)

This app is very similar to *Brushes* and if you are confident with that app, *Procreate* will feel instantly familiar to you. The main difference is the addition of a smudge tool (see page 72). As the name might suggest, there are more professional-level features than in *Brushes*, such as the ability to export in different file formats and selection tools. A great app, well worth the money.

PROS: Includes nice quality brushes, a smudge tool, editable brushes to create your own shape, multiple layers, and is compatible with the iPad Pro and Apple Pencil stylus.

CONS: The complexity can be overwhelming at first, and it is only available on iOS devices.

ARTRAGE

Price: £3.99 ($4.99)

A digital art box with simulations of pastels, oil paints, watercolours and more. This popular art app has brushes that are designed to act and perform like real paintbrushes. It also allows you to import and manipulate photographs, as shown here. Combined with its great layers functions, you can use this to build on your photographs.

PROS: Wide choice of tools, layers, large colour palette, metallic paint option, available for both iOS and Android devices.

CONS: The choice of tools can be overwhelming, and brushstrokes appear very slowly on screen, even on a current device.

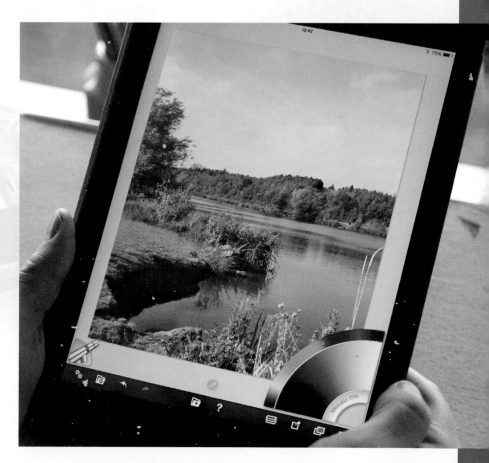

Painting tools

One of tablet art's appeals is its immediacy. All you need is a tablet computer and a finger or a stylus. Although a stylus is not essential, they give more of a painting feel and allow you to achieve a greater level of detail. There are many on the market but all will work well and make a difference to your painting, allowing more detail to be achieved than with your finger. The nature of a brush stylus makes the 'digital painting' experience feel more realistic. Unfortunately, you cannot use any paintbrushes you already have, as the bristles need to be designed for touchscreens. On the other hand, one sizes fits all, as the application you use will allow you to change the size and type of stroke the stylus makes (see pages 22–24). As a result, you never need more than one brush stylus.

Styluses tend to have two types of tip: soft, blunt rubber tips and brush tips. Some styluses have both tips – one at either end, or one on the lid that covers the normal tip (as shown below).

Finger

Tablets use touchscreens, which means you can use your finger just like a pen or a brush with the art apps described. Your finger allows simple painting and is an obvious way to get started.

Stylus: rubber tip

These look and feel a little like the eraser at the end of some pencils. They are great for drawing and erasing mistakes, and because they tend to be smaller than your finger, allow you to paint with more detail.

Stylus: brush tip

A brush-tipped stylus mimics a traditional paintbrush and is the perfect tip for painting on your tablet. The brush stylus reacts like a paintbrush, giving a natural flow of digital paint. Until you use one, the sensation is hard to describe… but try one and you will be hooked!

My finger – you will have to use your own!

The Apple Pencil

Designed to work on the iPad Pro, this fine-tipped stylus is pressure- and angle-sensitive, for a range of marks. There is also virtually no lag (latency) between touching the surface and the brushstroke appearing.

A selection of styluses.

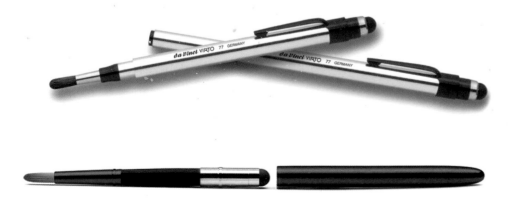

MATTHEW'S MATERIALS – MY PREFERRED PAINTING TOOLS

While you can paint with just your finger, I do recommend a stylus. My preferred stylus has a brush on one end and a rubber tip on the other. The brush gives a realistic painting feel, with the rubber tip giving a finer point. This is particularly good for sketching.

A common question I get asked is 'Can I use a normal paintbrush on my tablet?' The answer is simply: 'Try it and you will see it does not work'. This is because the digital stylus has special bristles to allow tablet screen painting.

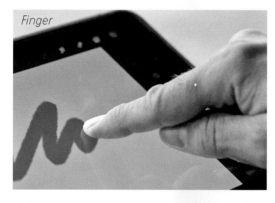

Finger

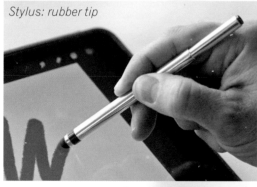

Stylus: rubber tip

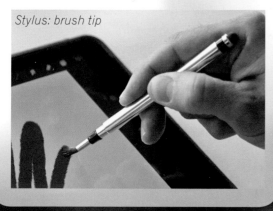

Stylus: brush tip

Essential techniques

As with any art medium, digital art involves its own techniques. Some, like how firmly you press on the screen, are very similar to painting with a real brush, while other techniques are less related to non-digital methods. For example, you can control the transparency of the chosen brush with a slider in most painting apps, which is equivalent to diluting watercolour paint with water. The following pages look at the core ideas, using the *Brushes* app as an example.

Setting up

To start a new painting, open the app and tap the new canvas symbol at the top right. It looks like a + sign. This will bring up a menu that presents you with a few options for canvas size. The default choice is normally the correct one for your tablet screen size, so you should not need to alter this – let the software work out what is best unless you have a specific purpose in mind for the painting. Once you tap 'Create', the blank canvas appears, and then the magic happens as you start to paint.

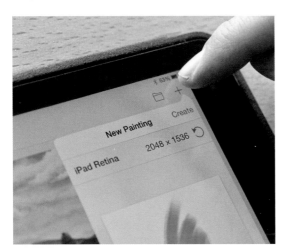

Turn on your iPad and select the app, then press the new canvas symbol to start a new painting.

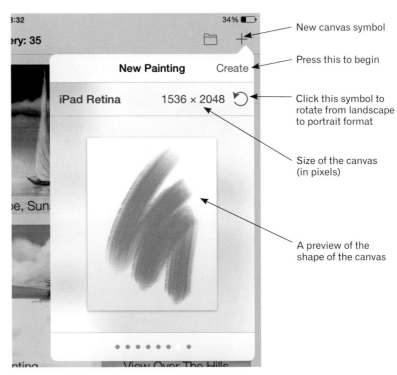

New canvas symbol

Press this to begin

Click this symbol to rotate from landscape to portrait format

Size of the canvas (in pixels)

A preview of the shape of the canvas

Setting up in other apps

Every app will differ to a larger or smaller extent from the others. The new canvas symbol in Procreate is within the gallery menu, for example. However, it is still a '+' sign located in the top right.

The painting surface

Once you set up a new painting, this is what your screen will look like. Think of the painting area like a canvas. The highlighted section at the bottom contains the controls – think of it like your paintbox. These are summarised below and explained on the following pages.

Toolbar Size slider

Starting other apps

The Procreate *painting surface is very similar to* Brushes, *but with most of the tools at the top, and the size slider at the right.*

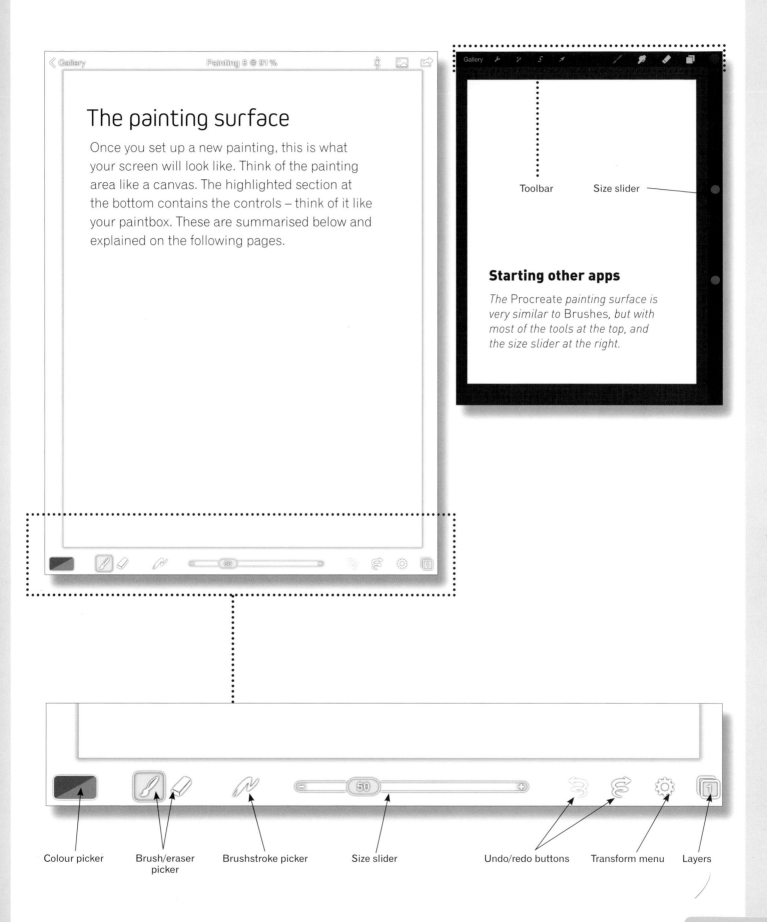

Colour picker Brush/eraser picker Brushstroke picker Size slider Undo/redo buttons Transform menu Layers

Gestures

These are the basic movements you use to paint. All of them will be familiar to anyone who has used a pencil!

 Familiarising yourself with the canvas and controls of your particular app can be handy, so spend a few minutes just playing around with the gestures and doodling on the canvas.

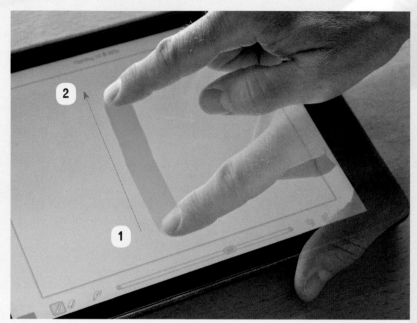

Smooth stroke

Place your finger on the tablet (1) and draw your finger smoothly to the end point (2) without lifting your finger. This gesture will be familiar from general use of your tablet.

Scribbling

Place your finger on the tablet (1) and work back-and-forth vigorously while working in a single direction. This is useful for quickly filling in areas and creating textures like grasses.

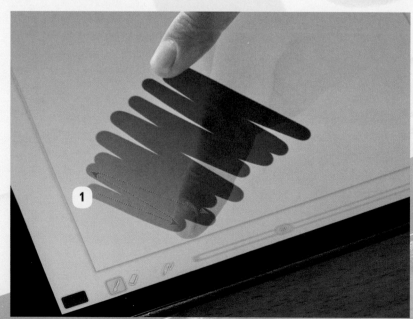

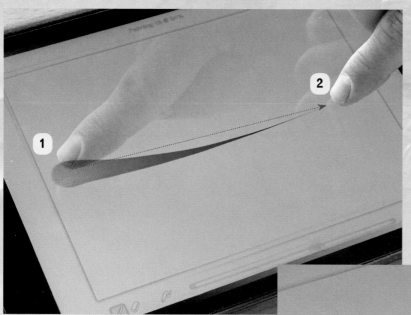

Flicking

This is a similar motion to the smooth stroke, but done much more quickly. In concert with brushes that use dynamics (such as the branch brush on page 30), this results in tapering strokes.

Circling

This motion is useful for building up texture such as hedges. Place your finger on the tablet surface (1) and simply work away, drawing tight loops.

Tapping

As with the smooth stroke, this tapping motion will be familiar to you from general use of your tablet. The longer and more firmly you press the tablet, the bigger the resulting paint 'blob' will be.

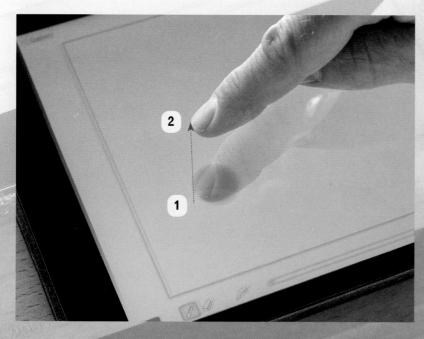

Navigating the canvas

As well as simply using the tip of a single finger to draw (see pages 18–19), you can use your fingers to perform different tasks on the screen of your tablet.

Moving the canvas

Moving two fingers together on the tablet screen will move the entire painting surface, rather than adding colour.

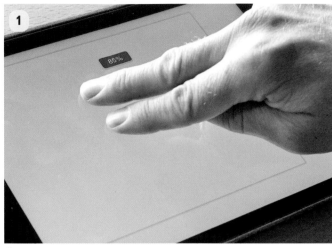 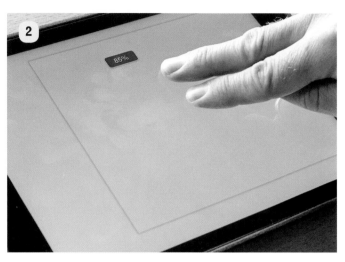

1 Place two fingers close together on the surface.

2 Move your fingers together. You will be able to see the border of the painting surface as a grey edge.

Zooming in or out

Closing your fingers together in a pinching motion allows you to zoom in and out on the app. This can be useful to look more closely at a particular part of your painting, or to work on fine details.

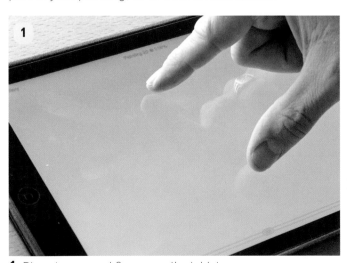

1 Place two spread fingers on the tablet screen.

2 Close your fingers together in a pinching motion.

Across the Meadow

This inviting landscape, with a river gently winding through a peaceful green valley, was created in Procreate, *and uses the smudge tool (see page 72) to create the effect of soft rain at the bottom of the clouds. It is a nice variation of the* View Over the Hills *project on pages 76–85.*

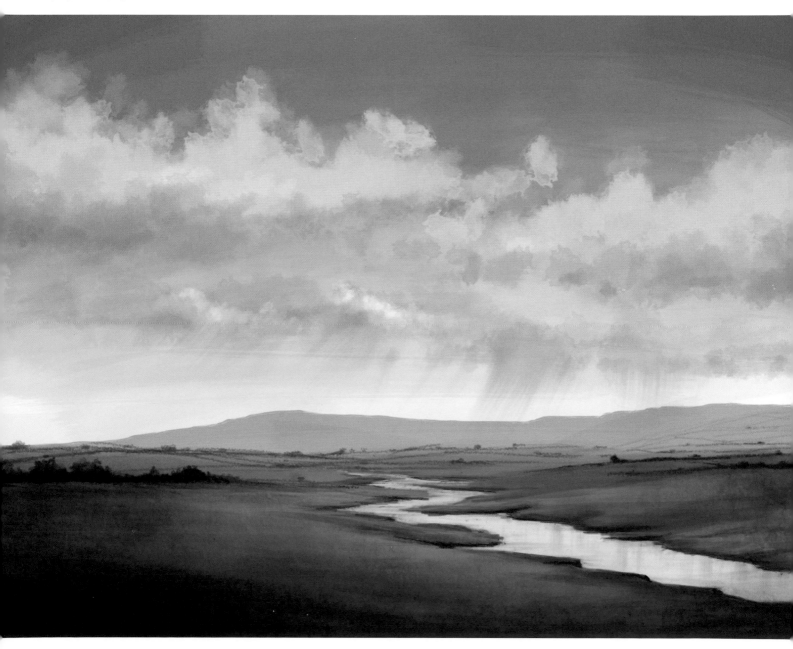

Creating your brushes

In the world of digital art you need only one brush. The software allows a single stylus brush to be a thousand, as the results of touching it to the screen will depend on the brush type you select in the app itself.

Each app has its own design of brush picker and these normally have some presets that you can use as a starting point. These can be edited at a later date to improve the way the brush works.

The sheer number of brush combinations available is part of what makes tablet art so versatile – you can recreate your favourite real paintbrushes, and you have access to brush types beyond what is possible in reality.

The brush picker

Tap the brushstroke symbol to open the brush picker. This will bring up some example brushes. The shape your touch will make on the canvas with the brush is previewed here, as shown below.

Selected brush
The brush you select will change colour when pressed and the 'edit' button will appear.

Brush effect
The shape in the middle shows the mark the brush will make on the canvas.

Brush size
The brush size is shown in the lower left. It is expressed in pixels.

Brush placement
Pressing and holding this allows you to rearrange the order of the brushes.

Brushstroke picker
Tap this to bring up the brush menu.

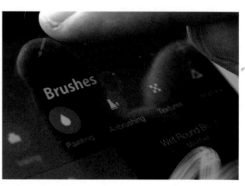

Choosing your brush in other apps

Most other digital painting apps have similar brush menus to that in Brushes. Procreate's is shown here. The underlying principles of the brush palettes in different apps tend to be similar, though they may differ in detail. For example, Procreate's brush menu is selected at the top right of the screen, rather than the bottom left.

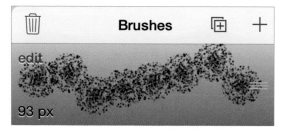

Editing properties

The selected brush will show a little 'edit' button at the top left. Pressing this will open up the individual brush properties. These can be adjusted to improve and alter the way the brush performs.

Editing the brushes

Each preset brush allows you to edit its individual properties. Each app is different, but they all basically use the same logic. For example, the brush picker in *Brushes* includes the option to increase or decrease the brush spacing, which allows you to create a broader or narrower brushstroke. You can then save these for future use.

There are many options, and my advice is simply to play around and doodle to learn what effect each setting has. Over time you will develop your own brushes as you work out what works best for you. To get you started, the following pages explain the brushes I use in the book, and show exactly what settings you need for each.

Brush preview
This shows the result the brush will make on the canvas with a single tap.

Brush tip
Each brush tip has its own special qualities and opens up different options.

Brush options
This shows the various options you have. The titles help explain what effect they will have, but I find it best to check against the brush preview as you move them.

Sliders
Moving the slider left and right will adjust the effect.

Number
This indicates the variable. Most sliders work from 0 to 100, but some work from –100 to 100, to more than 100, or work on a percentage system.

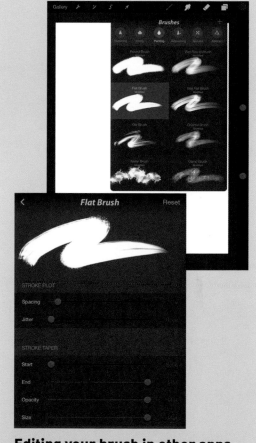

Editing your brush in other apps

The principle of selecting a brush from the menu and editing the details in a separate screen (see inset) is common to most painting apps. The exact details will vary, so experimentation is key. Nevertheless, almost every app will be able to approximate the brushes I suggest on the following pages, so whichever you choose, you will be able to follow.

The size slider

This appears at the bottom of the screen while you are painting, and is used to temporarily change the size of whatever brush you are using. Simply tap and hold the slider and run your finger to the left or right to decrease or increase the size.

The number on the slider shows you the size (in pixels) of the brush. If you need to return to the standard size – i.e. the size you set in the brush picker (see page 22) – simply reselect it from the brush picker.

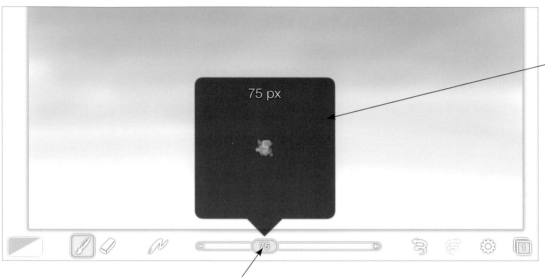

Size preview
A preview balloon will appear to show you how the brush will look as you move the slider.

Size slider
For quick reference while you work, the size of the brush is displayed in the middle of the slider at all times.

Adjusting the brush size in other apps

The size slider in Procreate appears at the side of the screen as shown here, and works on a percentage system instead of a fixed pixel size.

The eraser

Brushes allows you to use your brushes to remove paint as well as apply it. To do this, simply select the eraser option at the bottom of the screen. Most apps have a similar function to remove paint.

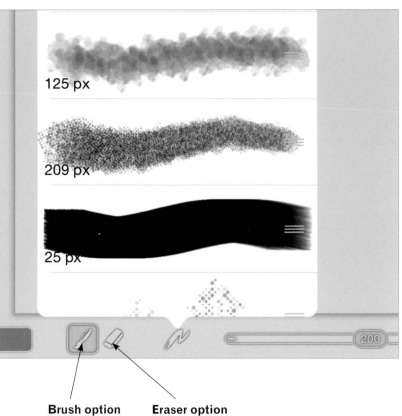

125 px

209 px

25 px

Brush option **Eraser option**

Using the eraser in other apps

As I have mentioned, different apps have different strengths and weaknesses. Procreate has a particularly useful feature on its eraser – you can adjust the strength of it to remove different amounts of colour, as shown above. This allows you to use techniques similar to lifting out in traditional watercolour painting. To adjust the eraser strength, lower the brush opacity slider.

My brushes

On the following pages I give you a list of settings that you can copy to make a range of digital brushes. These are the brushes I find myself using all the time – and so they will be used throughout this book, which makes the brushwork both easy and straightforward.

I have used the *Brushes* app throughout (the current version is called *Brushes Redux*), but don't worry if you prefer another app. All art apps will have slightly different names for the settings, but the great thing is you can see the brush change in real time, and thus you can create approximations of each of these brushes in whichever app you like. The changes in the slider values listed alter the characteristics of the brush – so your gestures and movements will create different results depending on the changes you make when editing the brush.

Due to the number of options, there is a dizzying array of brush-shape possibilities. Most art apps come with some standard brushes installed. For this book, I suggest you recreate brushes similar to those described on the following pages. The ten listed are versatile brushes that will let you paint any of the projects in this book.

You will need a selection of brushes for your tablet, just as you would for a traditional painting.

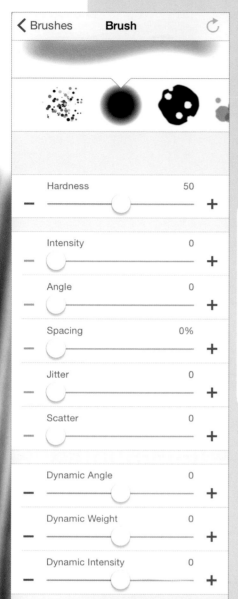

The default round brush

The brushes are all explained in terms of the default round brush shown on this page. Where a value is not shown overleaf, it is the same value as shown here under the default round brush.

In *Brushes*, each brush also has a tip, which changes the option sliders (see Brush tips, below). This is pictured at the top right of each brushstroke picture, so you know which one to pick.

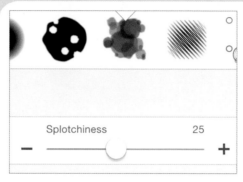

Brush tips

Some apps, including Brushes, *have different types of brush tip. These tips often have different option sliders; some in place of others, some in addition to those found on the default round brush.*

For example, the splotchy brush tip shown here replaces the 'Hardness' slider of the default round type with a 'Splotchiness' slider. Where these values are not listed, stick with the default value.

Default round brush

The default size for this general-purpose brush is 150px.

Hardness: 50	*Jitter: 0*
Intensity: 0	*Scatter: 0*
Angle: 0	*Dynamic angle: 0*
Spacing: 0%	*Dynamic weight: 0*
	Dynamic intensity: 0

Large wash brush

Perfect for the base wash, and ideal for painting skies, the large wash brush differs only slightly from the default round brush.

Reduce the hardness to create a softer-edged brushstroke. Softer-edged brushes allow different colours to blend together better.

Differences from the default round brush:
Size: 200px
Intensity: 10

Small wash brush

This is perfect for filling in smaller areas, like buildings and trees. You can reduce the intensity to create a lighter brushstroke, which is great for glazing one colour over another.

Differences from the default round brush:
Size: 50px
Intensity: 25

Detail brush

This is your equivalent to a rigger brush – it is the brush used for the fine work, like the fine branches of a tree.

Do not be afraid to reduce the size down as low as 1px. Remember that you can pinch to zoom in really close for those very fine details.

Differences from the default round brush:
Size: 3px
Hardness: 75
Intensity: 50

Foreground foliage brush

This brush is ideal for painting a woodland scene. The large dynamic angle and low dynamic weight of this brush mean that if you brush across the paper quickly, the paint stroke will taper off. This makes it ideal for close-up tree foliage.

Differences from the default round brush:

Size: 200px	*Spacing: 75%*
Bristle density: 1	*Jitter: 100*
Bristle size: 75	*Scatter: 100*
Intensity: 75	*Dynamic angle: 50*
Angle: 125	*Dynamic weight: –50*

Midground foliage brush

A brush used for general painting, this allows you to create useful textures, perhaps most importantly mid-sized trees.

Reducing the bristle size setting will give a more open look to your tree, which is great for a tree where you can see through the branches, like a silver birch.

Differences from the default round brush:

Size: 100px

Bristle density: 1	*Spacing: 5%*
Bristle size: 100	*Jitter: 50*
Intensity: 100	*Scatter: 50*
Angle: 100	

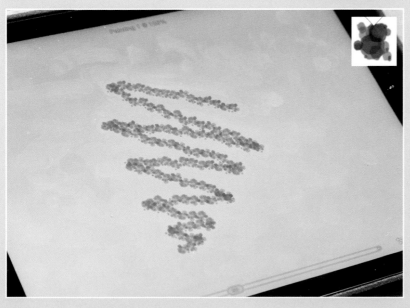

Distant tree brush

Generally used with circular gestures, this brush will help paint distant hedgerows and trees, as well as smaller foliage. Reduce the spacing percentage and scatter to bring the splotches closer together and give a tighter look to the brushstroke.

Differences from the default round brush:

Size: 50px	*Spacing: 75%*
Splotchiness: 25	*Jitter: 50*
Intensity: 100	*Scatter: 50*
Angle: 0	

Cloud brush

The technique to paint clouds is to simply twist your finger or stylus to give a 'cotton wool' feel. Very similar to the distant tree brush, the cloud brush gives a softer, less intense result. You can reduce the intensity further to give a softer feel to your clouds.

Differences from the default round brush:

Size: 125px

Splotchiness: 25

Intensity: 25

Spacing: 25%

Jitter: 25

Scatter: 25

Texture brush

Used to give final bits of texture to grassy areas, mountains, stone walls or similar areas, this brush is very versatile.

 The opacity can be reduced to make the brush more translucent, which is great for adding a light glaze of texture with this brush.

Differences from the default round brush:

Size: 50px	*Jitter: 75*
Bristle density: 15	*Scatter: 15*
Intensity: 35	*Dynamic angle: 0*
Angle: 225	*Dynamic weight: –50*
Spacing: 10%	*Dynamic intensity: –25*

Branch brush

The low settings for dynamic weight and dynamic intensity give a wonderful 'flick or fade' to this brush, perfect for fine branches. Practise fast strokes with your finger or stylus as you paint towards the tips of the fine branches. You should see the branches fade out. The faster your flick, the thinner the brushstroke.

Differences from the default round brush:

Size: 5px	*Dynamic scale: 25*
Bristle density: 30	*Dynamic weight: –100*
Intensity: 100	*Dynamic intensity: –75*
Angle: 175	

View over Derwent Water

A peaceful scene of sailboats. This painting of the wonderful Derwent Water in the Lake District, UK, features all the brushes on the previous pages; including the large wash brush used for the dark corners and sky, the cloud brush for the clouds, and the texture and foliage brushes for the greenery.

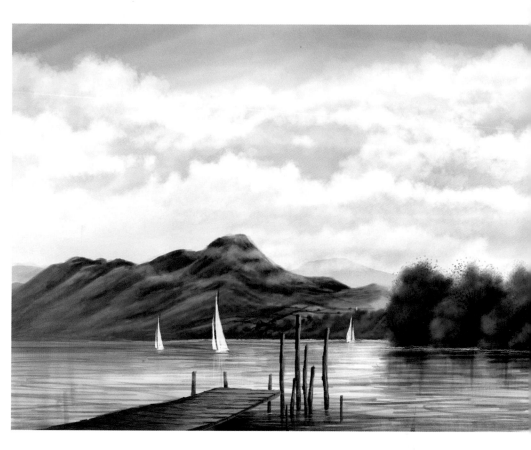

Winter in the Peaks

This moody painting is completed in just tones of grey. Nevertheless, the variety of brush types used ensures it is full of interest and shows how effective monochrome work can be on your tablet.

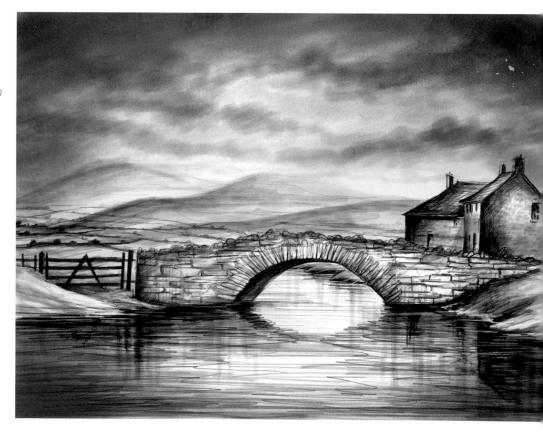

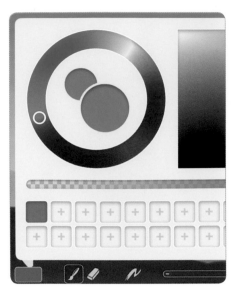

The colour menu

Tap the paint pan symbol on the lower left to open the colour menu. This will bring up the palette, the colour wheel, the tonal block and the opacity slider.

Colour basics

Mixing colours

Choosing or mixing colours in digital art is very much like preparing real paints. You start by picking the basic hue – imagine this to be choosing a particular tube or pan from your box of paints. In most apps, this is done using a colour wheel similar to that shown on this page. Once you have chosen the hue, you can use alter the tone of the colour you picked. In *Brushes*, this is done with the tonal block. The tonal block is equivalent to your mixing palette, where you can add white or black to adjust the lightness or darkness of the hue.

The final part of the colour menu is the opacity slider. This makes the colour more or less opaque – a little like adding water to pure paint. This allows you to create subtle washes and glazes, which are key to creating beautiful digital artwork.

Colour wheel

This allows you to select a pure hue – the equivalent to paint straight from a tube. Run your finger around this circle to choose the general colour you wish to use to paint.

Tonal block

Once you have picked the hue from the colour wheel, you can press and hold your finger in this area to alter the tone and intensity. The lightest tones are at the top, and the darkest at the bottom. The right-hand side of the block gives you more saturated, vibrant colours, and the left-hand side is desaturated and subtle.

Colour well

Think of this like a palette well. Once you have mixed your colour, it will appear in the large circle here. The previous colour will appear in the smaller inset circle, allowing you to make quick comparisons.

Opacity slider

Altering this slider is equivalent to diluting your colour, just like adding more water to watercolour or acrylic paint. Simply move the slider from right (full strength and opaque colour) to left (no colour at all, completely transparent).

Preparing your colours in other apps

Other art apps will have slightly different colour pickers and palettes, but they all do the same job and work in much the same way. Shown here is the Procreate version. The major difference is that the tonal block is located in the centre of the colour wheel.

Creating your palette of colours

Once you have mixed your colour, you can save it to the palette by clicking one of the empty wells below the colour menu. These are shown as '+' symbols.

This is a very useful feature if you have colours you use a lot, such as greens for trees or blues for skies. You can simply save them for later use, allowing you to switch between colours without having to mix them time and again.

The palette

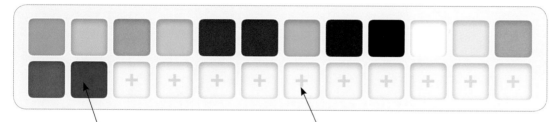

The colour is stored in the palette by pressing a well. Click on the well again to reselect a particular colour later.

Empty wells are shown as + symbols.

Cleaning your palette

You can also delete the saved colours and start again, simply by dragging one of the empty wells (signified by the + symbol) over the colour. It is almost like wiping your paint palette clean.

Cleaning your brush in other apps

To clean a well in Procreate, simply press and hold the colour in the palette and drag it outside the area.

Getting started

With the basic theory under your belt, we can now start to paint without paint. The exercises on the following pages are designed to ease you into painting with your tablet by producing a variety of simple landscapes. Even if you are already confident with your tablet, I suggest you work through these exercises in order to understand how you create the colours used in the later demonstrations, and to practise using the different brushes.

Exercise 1: Simple sky

This exercise will introduce you to how to use your tablet for painting and allow you to produce a clear blue sky that softens from a vibrant blue to a paler tone towards the horizon. This exercise uses just one brush, and is a little like a graded wash in watercolour.

To begin, open the *Brushes* app and set it up as described on page 16. Next, choose the size relevant to the tablet on which you are working – in this case, 1536 x 2048px for an iPad Air. Make sure that the picture is in a portrait orientation and press 'create'.

1 Pinch your fingers inwards so that you can see the edges of the painting surface.

2 Pick the colour you would like the sky to be. I suggest a colour close to cerulean blue. The exact hue does not matter, but make sure that the opacity is at one hundred per cent, and that the tone is as strong as possible. Store this colour in your palette by pressing the + symbol in one of the spare swatches at the bottom.

3 Choose the large wash brush (see page 28).

4 Starting from the top of the painting surface, run your finger smoothly back and forth, working downwards in horizontal strokes to roughly a third of the way down. Do not leave any gaps.

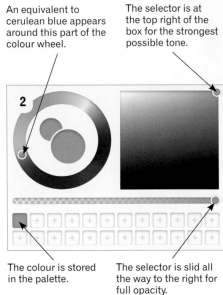

An equivalent to cerulean blue appears around this part of the colour wheel.

The selector is at the top right of the box for the strongest possible tone.

The colour is stored in the palette.

The selector is slid all the way to the right for full opacity.

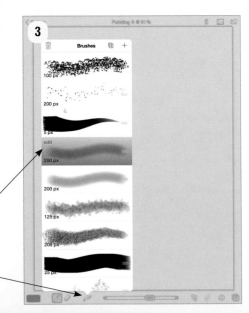

Your pre-prepared large wash brush looks like this.

Tap this symbol to bring up your brushes.

The swatch from which you are working (full strength here) can be seen in the small circle.

The tone remains the same as before.

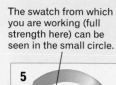

Slide the selector to a quarter of the way from the left.

You will be able to see the chequered background in the large circle when the colour is transparent.

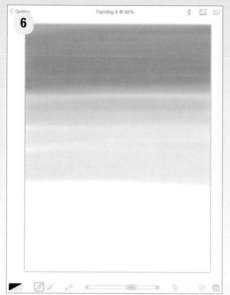

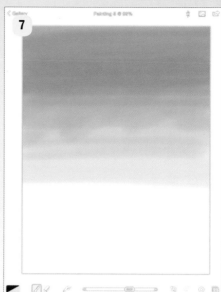

The previous twenty-five per cent opacity can be seen here for comparison.

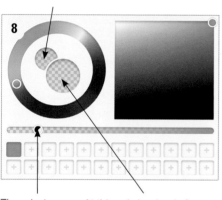

The selector is slid nearly all the way to the left.

At this pale low level of opacity, the chequered background is very obvious.

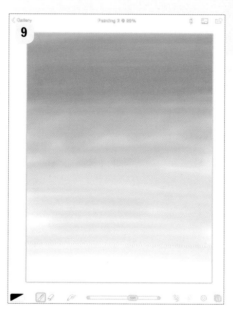

5 Reduce the opacity of the colour to roughly twenty-five per cent.

6 Cover the middle third of the painting surface as before, using smooth horizontal strokes.

7 Blend the join between the two areas with diagonal strokes that run between the top and middle thirds of the surface.

8 Reduce the opacity of the colour to ten per cent.

9 Work down into the bottom third with smooth horizontal strokes as before.

10 Still using the large wash brush at ten per cent opacity, smooth out any rough areas or visible marks across the sky using quick strokes at diagonal angles.

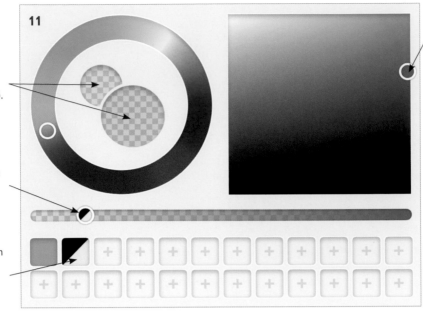

You can compare the new colour you are creating (large circle) with the previous one (small circle). Use this to make sure you are deepening the tone sufficiently.

The transparency remains the same, at roughly ten per cent.

When you store a colour in the palette with changes made to the opacity, the swatch will appear split like this.

Moving the selector down deepens the tone.

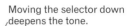

11 Darken the tone of the colour a little by moving the selector down towards the black area at the bottom of the box. Keep the selector close to the right-hand side to ensure the hue remains as blue as possible. Store this tone in your palette by pressing one of the spare swatches.

12 Use the large wash brush to apply the dark tone in the top corners of the sky, using slightly curved strokes. Darkening areas near the edge of your painting helps to keep the viewer's eye within the picture, an effect called 'vignetting'.

13 Use repeated overlaying curved strokes to build up the tone in the top of the sky. Transparent colours allow you a lot of freedom in building up the tone gradually, so you do not end up with obvious finger marks.

13

The completed simple sky

Sky in context

Adding some distant mountains below the sky turns the picture into a simple landscape. See pages 39–40 for how to paint mountains.

Exercise 2: Landscape with cloudy sky

Building on the previous exercise, the following pages show you how to turn a simple sky into a full landscape, with clouds and distant rolling hills in the background. It introduces you to changing between and editing brushes – just like swapping between real brushes.

1 Build up a simple sky as before (see pages 34–37).

2 Add a white swatch at seventy-five per cent opacity to your palette.

3 Select the cloud brush.

4 Add a large bank of clouds in the top third of the picture with small circling motions of your finger. Keep the cloud bank broadly horizontal and make them taller towards the edges of the painting surface.

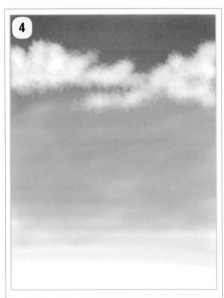

The basic hue is irrelevant when you are making white.

Taking the selector to the top left of the box will always create pure white.

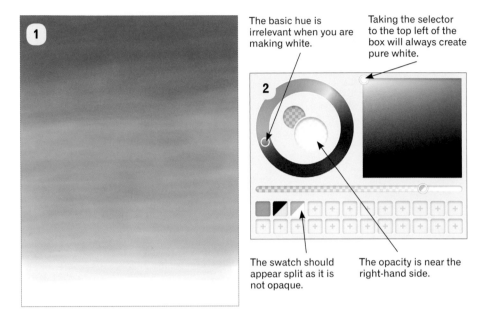

The swatch should appear split as it is not opaque.

The opacity is near the right-hand side.

The cloud brush will appear like this in your brush selection.

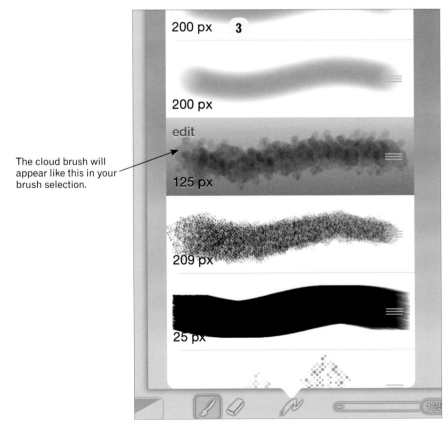

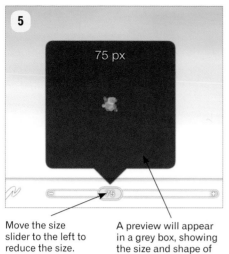

Move the size slider to the left to reduce the size.

A preview will appear in a grey box, showing the size and shape of the mark your finger will make.

As with white, the basic hue is irrelevant.

The selector is on the left to remove all hue (desaturate) from the colour.

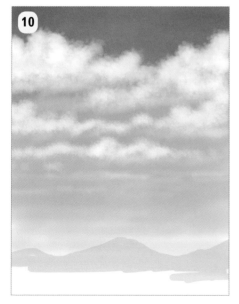

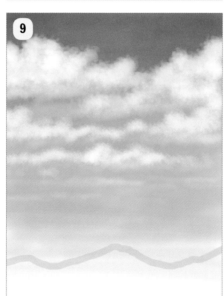

5 Reduce the brush size to 75px.

6 Add some smaller bands of cloud below the first using smaller finger motions. Taper the clouds away at the ends with small tapping touches.

7 Reduce the opacity to around thirty-three per cent and store the colour in your palette. Use this softer white to blend the lower parts of each cloud bank into the sky, then reduce the brush size to 50px and add some very faint clouds in the distance with small horizontal strokes and a few overlapping taps to suggest shape.

8 Change to the small wash brush and pick a colourless grey at twenty-five per cent opacity. Add this to your palette.

9 Keeping your finger on the screen throughout the movement, add a line of hilltops approximately a quarter of the way up from the bottom.

10 Still keeping your finger down to avoid banding, begin to fill in the area beneath the skyline.

11 Continue filling in down to the bottom of the painting surface, being careful not to lift your finger away.

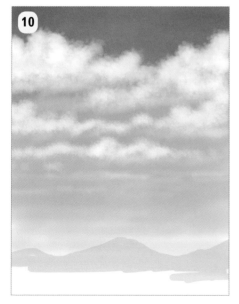

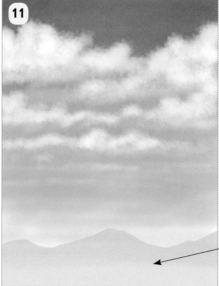

Because the opacity is low, you can see the sky behind the top part of the hills at this point.

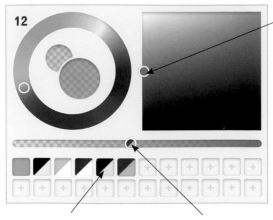

12

The selector remains at the same place in the tone box.

12 Increase the opacity to fifty per cent and add it to the palette.

13 Keeping your finger on throughout, add a darker line within the first as the tops of midground hills.

14 As for the distant hills, fill in the area below the line down to the edge of the painting surface.

15 Repeat the process to add foreground hills, using a seventy-five per cent opacity grey to finish.

The different opacities can be distinguished easily.

The opacity slider sits in the centre of the bar.

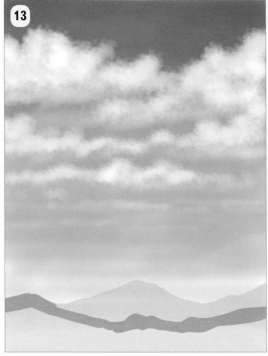

13

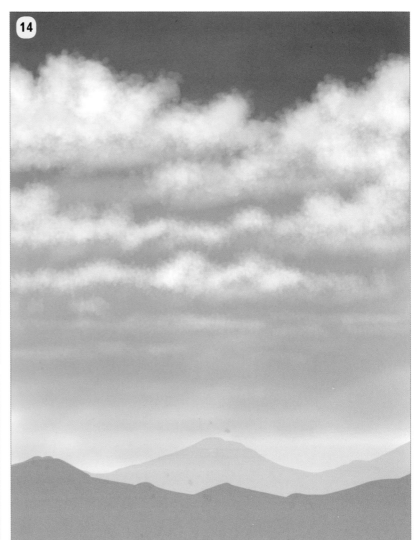

14

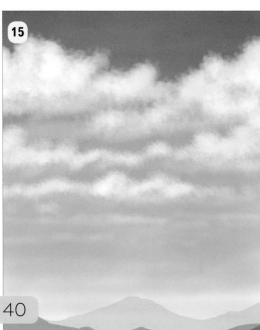

15

The completed landscape with cloudy sky

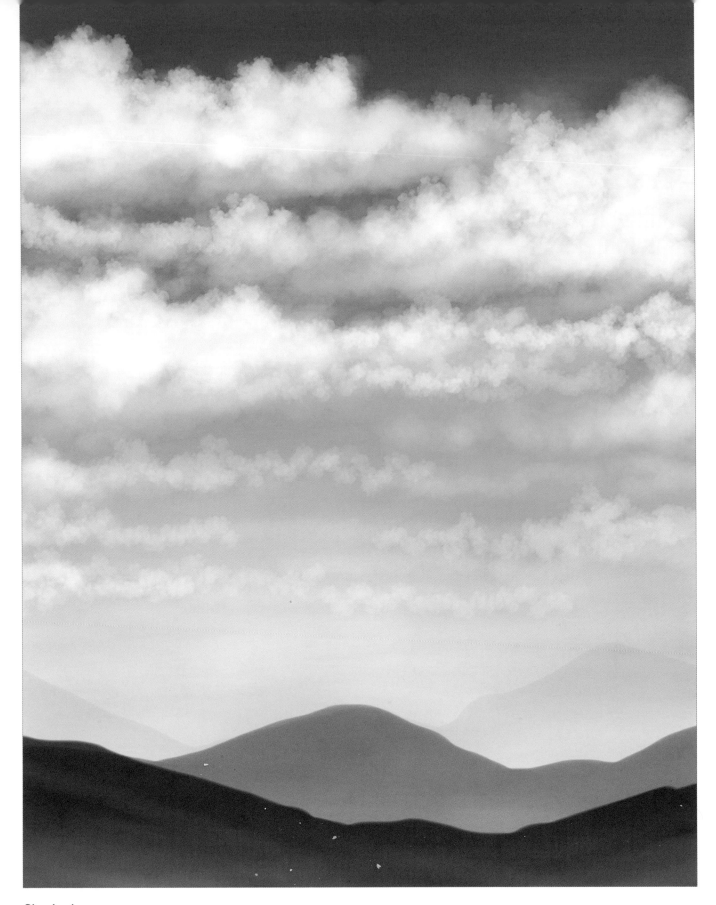

Cloudy sky

This more developed sky and landscape was built up in exactly the same way as the exercise – simply with more layers used and time taken.

Exercise 3: Landscape with sunset

At this point, you should be fairly comfortable with the brushes and movements of your finger, so this final exercise builds on the previous two by concentrating on using colour and adding interest to your painting.

Open the *Brushes* app and set it up as described on page 16. Next, choose the size relevant to the tablet on which you are working (in this iPad Air example, that is 2048 x 1536px). Make sure that the picture is in a landscape orientation and press 'create'. To begin, add the following colours to your palette: midnight blue, warm yellow and peach.

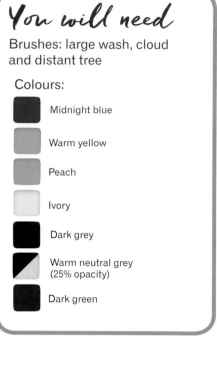

You will need

Brushes: large wash, cloud and distant tree

Colours:

- Midnight blue
- Warm yellow
- Peach
- Ivory
- Dark grey
- Warm neutral grey (25% opacity)
- Dark green

Tip

You can use your judgement when selecting colours, but if you prefer to copy more exactly, use the swatches to the right to help guide your choice. The examples in this box will help you get the initial colours as near as possible.

Place the selector as shown to get similar colours to those I used.

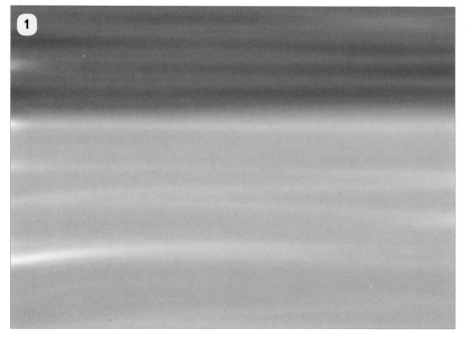

1 Using the large wash brush, add three blocks of colour as shown: blue at the top, yellow in the middle and peach at the bottom.

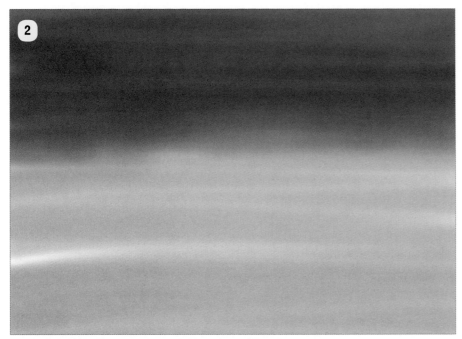

2 Reduce the opacity of the blue to twenty-five per cent and work horizontal strokes from the top down to halfway, working over the top of the yellow area.

3 Blend the yellow area into the peach in the same way, reducing the yellow to twenty-five per cent opacity and working from halfway down over the top of the peach area.

4 Add an ivory swatch to your palette at seventy-five per cent opacity. Reduce the brush size to 100px and use a circular motion to add a small sun in the lower right of the painting area.

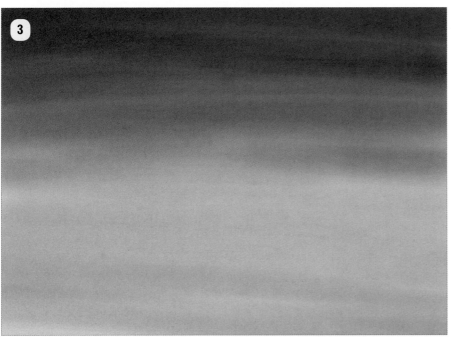

5 Reduce the opacity to fifteen per cent and use circular movements to soften the edges of the sun, and horizontal strokes to add a glow at the same level as the sun.

6 Reduce the opacity to between five and ten per cent and add some rough sunbeams radiating from the sun. Use quick, straight strokes.

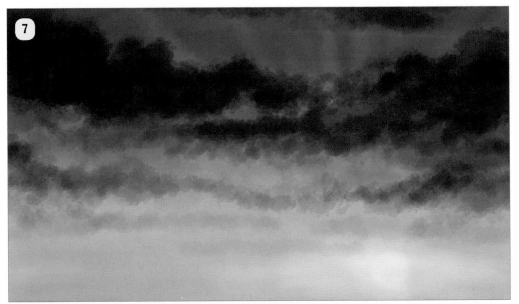

7 Add a dark grey to your palette. Change to the cloud brush and use the new colour to add clouds as described on pages 38–39. Add the clouds to the top half only, ending them before they reach the level of the sun.

8 Edit the cloud brush as follows: increase intensity and jitter to 50, the spacing to fifty per cent and reduce the size to 50px. Use this to add highlights to the bottom of the clouds, using the ivory swatch at roughly fifty per cent opacity.

9 Reduce the opacity to twenty-five per cent and soften in the highlights. Add a few hints of the peach at twenty-five per cent opacity too, using the same altered cloud brush.

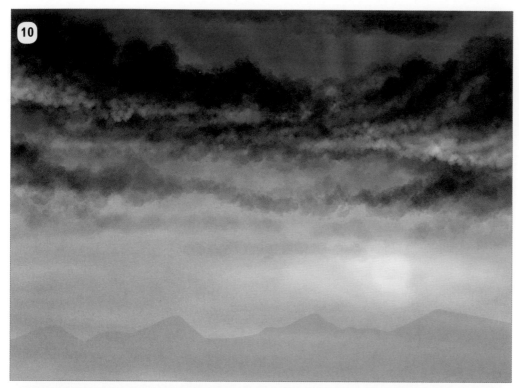

10 Change to the small wash brush, add a warm neutral grey to your palette at twenty-five per cent opacity. Use this to add a skyline below the sun. Do not lift your finger away as you work.

11 Add a dark green to the palette, then use the distant tree brush to add a loose woodland effect in the lower corners of the painting area. Use the same small swirling movements as the clouds to get the loose texture of the trees.

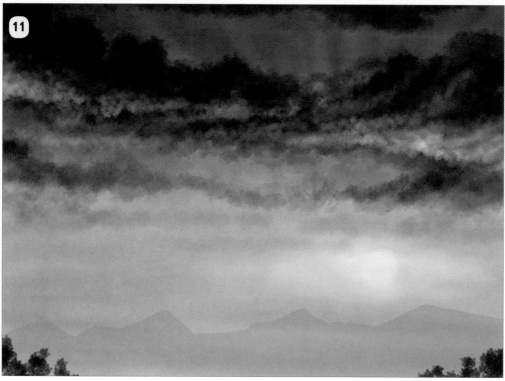

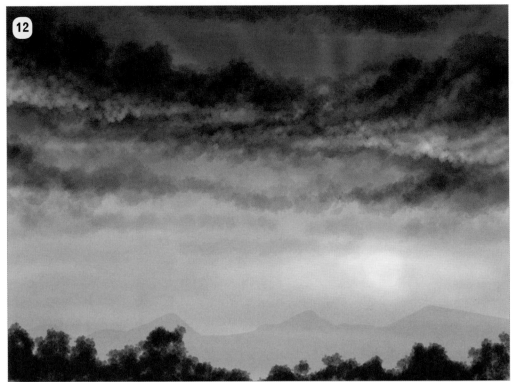

12 Build up the woodland in the same way all across the bottom of the painting area. Add more trees to the sides than to the centre, in order to keep the eye within the painting.

The finished painting.

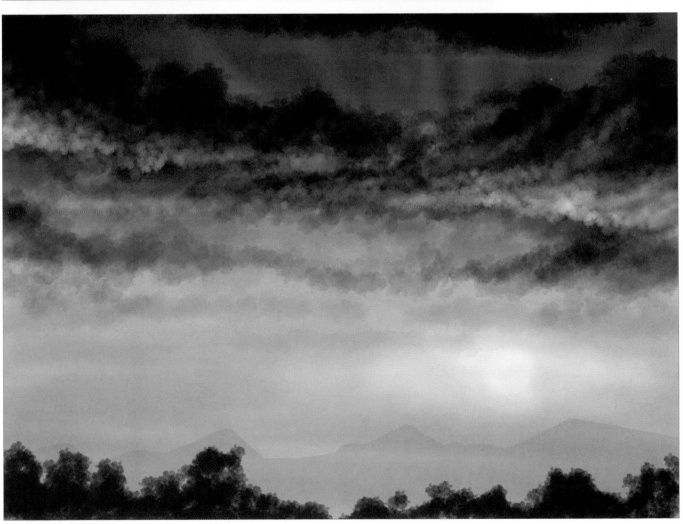

Using the stylus

At first, I just used my finger for digital painting. But having tried using one, my stylus now rarely leaves my side. Styluses have been around ever since we have had touchscreen devices. They give the user a greater level of input, with higher accuracy, and this is particularly important when painting on your tablet.

Most styluses have just a soft rubber tip at one end. However, the type I prefer to use has a rubber tip on one end and a brush on the other. The first time I used a brush stylus, my reaction was surprise. It really does feel as though you are painting, giving a natural flow of digital paint. For a traditional artist like me, that was important.

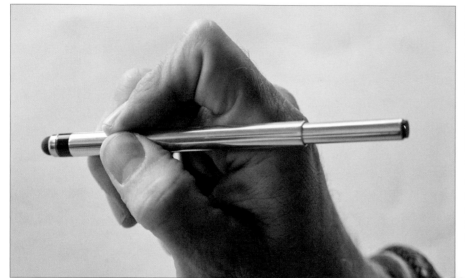

The stylus can be held, and used, just like a pencil or pen (see above). This is particularly relevant when using the rubber tip because it feels familiar and natural, giving you control so you can achieve precise results.

Using the soft tip

The soft tip is great for pencil style drawing, and useful for erasing mistakes. Using it feels a little like using the eraser on the end of some pencils. For me this tip does not get much use as I love using the brush. However, it is excellent for clean detail lines and also for use with the eraser brush. The soft tip is also perfect for a very important job – signing your finished masterpiece!

Using the brush tip

The perfect tip for painting on your tablet: that says it all. I use this for skies, trees, water, buildings... In fact, nearly all of my iPad/tablet artworks are painted with this type of stylus.

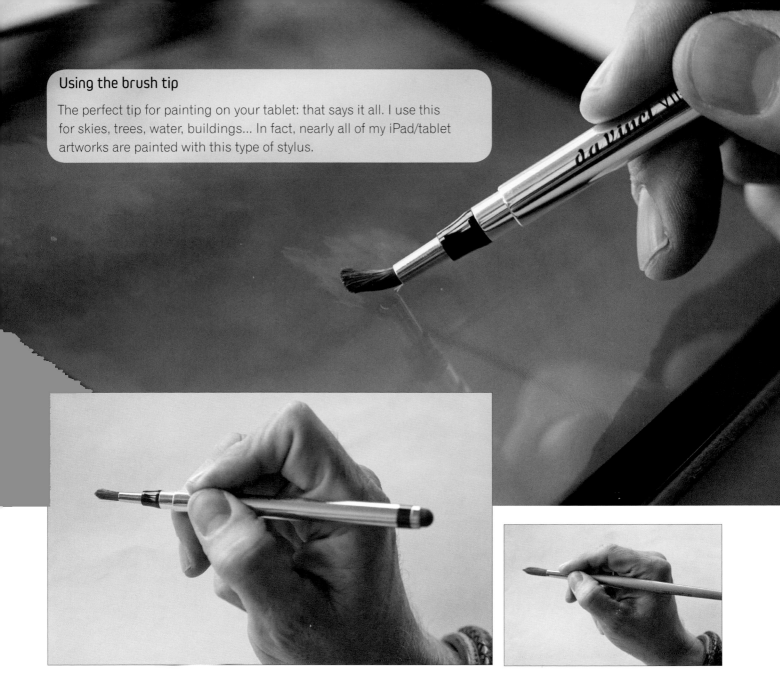

Held just like a real paintbrush (see above right), the brush tip of a stylus allows more freedom of movement on the tablet surface. While giving you slightly less control than the soft tip, this helps to create a more painterly and pleasing result.

Tip

Over time the hairs on your brush stylus will become splayed due to heavy contact on the tablet screen. It is possible to rejuvenate them from time to time by dipping the tip in hot (but not quite boiling) water for a few moments. This brings the shape back.

Landscape essentials

Now you have had a chance to learn the basics like colours and brushes, and you have had a go at painting skies, it is time to move on to landscape essentials: trees, figures and buildings. These are important to add interest to your landscape paintings, and learning how to paint them will develop your skill with the stylus.

Once you have learned the basic approach for these objects, you can alter the shape and colours to suit yourself. Because we are working digitally, you can save them and drop them into a finished landscape later on through the layers palette. For now, just remember to save your work as you go. All of these tutorials are painted with a stylus.

Winter trees

Set up a new canvas and make a dark brown and a light brown, both at full opacity.

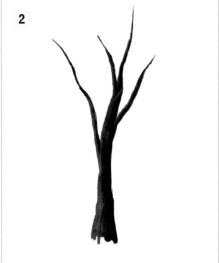

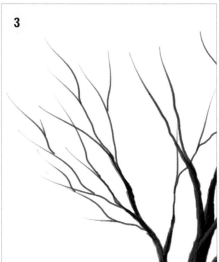

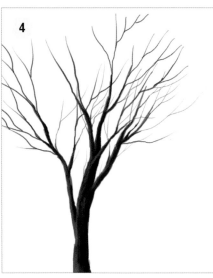

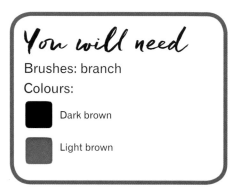

You will need

Brushes: branch
Colours:

Dark brown

Light brown

1 Increase the size of the branch brush to 25px and draw in a trunk, making it taper towards the top by using a slight flicking motion of the stylus. Decrease the size of the brush to 10px, change to the light brown and reduce the opacity to fifty per cent. Add some highlights on the left-hand side.

2 Change to dark brown and add three or four large branches. Paint in the direction of growth using a short scribbling action and taper the branches towards the ends. Add highlighting strokes of the semi-transparent light brown on the left-hand sides.

3 Using the branch brush on the standard settings (see page 30), add more fine branches with dark brown. Use light flicking motions.

4 Reduce the opacity to fifty per cent and continue adding fine branches. This creates the impression these branches are in the background.

5 Add highlights using the branch brush at sizes between 5 and 10px, depending on the size of the branch.

6 Zoom in and use the same brush and techniques to extend the highlights from the main branches onto the tree to add further shape.

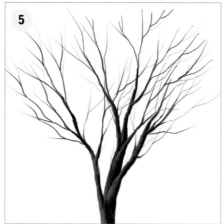

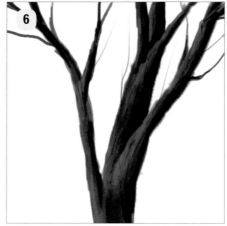

The finished winter tree

This completes the basic winter tree, suitable for later use. If it is intended as a focal or foreground object, you can add further detail, as shown.

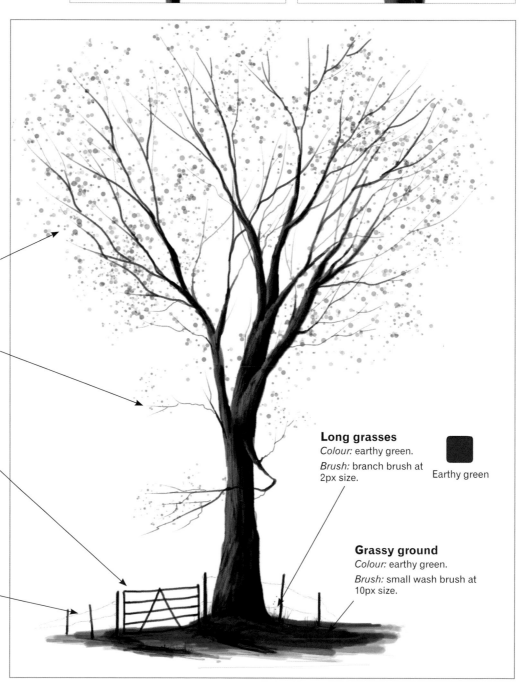

Sparse foliage
Colour: light brown at full opacity.
Brush: foreground foliage brush.

Additional fine branches
Colour: light brown at full opacity.
Brush: branch brush.

Fence and gate
Colour: dark brown at full opacity.
Brush: small wash brush at 10px size.

Barbed wire
Colour: dark brown at full opacity.
Brush: fine detail brush.

Long grasses
Colour: earthy green.
Brush: branch brush at 2px size.

Earthy green

Grassy ground
Colour: earthy green.
Brush: small wash brush at 10px size.

Summer trees

Set up a new canvas and add the following colours to your palette, all at full opacity: light green, dark green, light brown, dark brown.

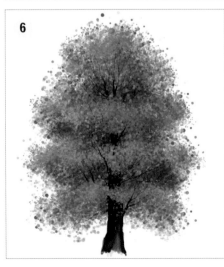

You will need

Brushes: midground foliage brush, branch brush
Colours:

Light green

Dark green

Dark brown

Light brown

1 Using the midground foliage brush, use tapping motions to build up a large, roughly egg-shaped mass of light green. Leave a few gaps near the edges but keep the centre fairly solid.

2 Reduce the opacity of the dark green to seventy-five per cent. Change the brush size to 75px and scatter to 100 and add three loosely horizontal areas to the tree as shown.

3 Reduce the brush size to 50px and opacity to fifty per cent. Build up the dark areas with light, tapping strokes of dark green. Zoom in for extra control.

4 Using these two colours, build up the foliage. Gradually build the brush size back up to 125px while reducing the opacity of the light green to fifty per cent. Keep the colours in the appropriate areas.

5 Change to the branch brush and use dark brown to block in the trunk with short up-and-down strokes, avoiding the lighter green areas.

6 Add highlights to the trunk and finer branches as for the winter tree (see pages 50–51), then change to the midground foliage brush. Increase the scatter to 100, reduce the opacity of the light green to seventy-five per cent and use it at a brush size of 125px to add looser leaves at the edges. To finish, bring the light green to full opacity and add highlights here and there.

The finished summer tree
You can develop the summer tree into a full painting using the notes on this page.

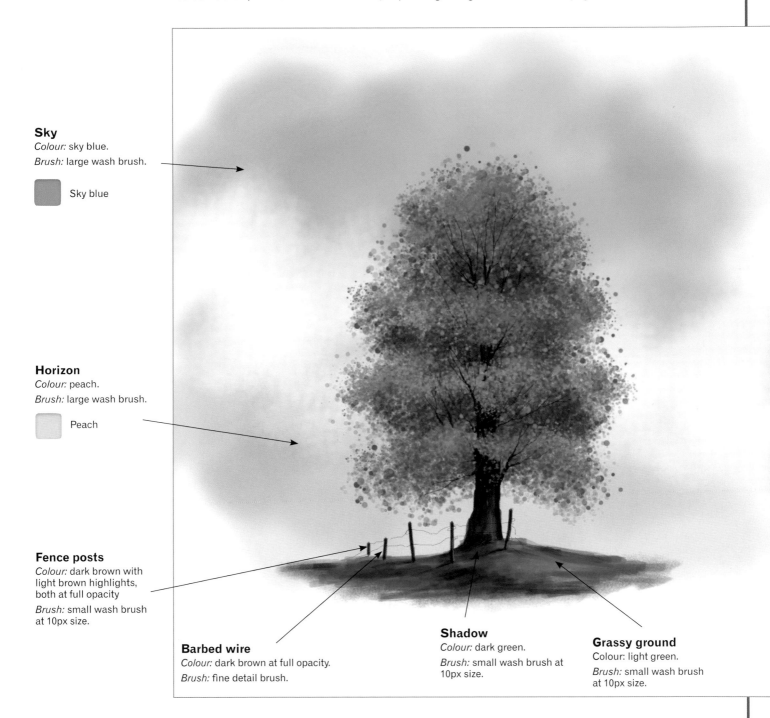

Sky
Colour: sky blue.
Brush: large wash brush.

Sky blue

Horizon
Colour: peach.
Brush: large wash brush.

Peach

Fence posts
Colour: dark brown with light brown highlights, both at full opacity
Brush: small wash brush at 10px size.

Barbed wire
Colour: dark brown at full opacity.
Brush: fine detail brush.

Shadow
Colour: dark green.
Brush: small wash brush at 10px size.

Grassy ground
Colour: light green.
Brush: small wash brush at 10px size.

Figures

Set up a new canvas and add the following colours to your palette, all at full opacity: light skintone, dark skintone, red-brown, blue-black and black.

You will need

Brushes: detail brush
Colours:

- Light skintone
- Dark skintone
- Red-brown
- Blue-black
- Black

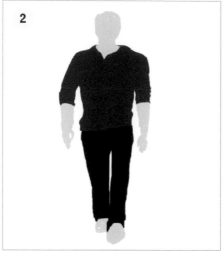

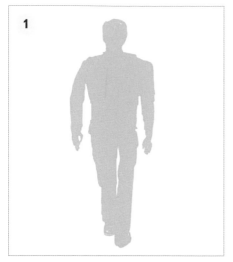

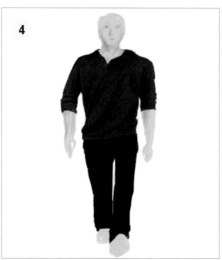

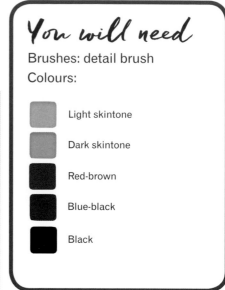

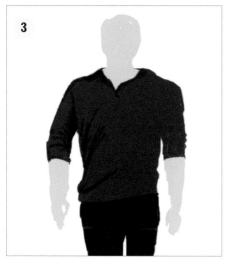

1 Draw a simple silhouette of a figure walking using the light skintone and the detail brush at 10px size.

2 Change the brush size to 7px and colour in the shirt using the red-brown and the trousers using blue-black. Zoom in and change to 3px size for fine areas at the edges.

3 Keeping the brush size at 3px and using black at twenty-five per cent opacity, begin to build up tone to suggest shadows and form on the shirt and on the exposed skin, including the suggestion of features on the face.

4 Reduce the opacity to five per cent to blend the shadows in.

5 Add shoes using pure black at full opacity, then reduce the opacity to ten per cent and change the brush size to 5px. Use this to add a cast shadow around the feet with overlaying horizontal strokes.

6 Strengthen the shadow under the figure's jaw with the same opacity, then add hair with black at seventy-five per cent opacity. To finish, use the light skintone at five per cent opacity to add highlights to the clothes.

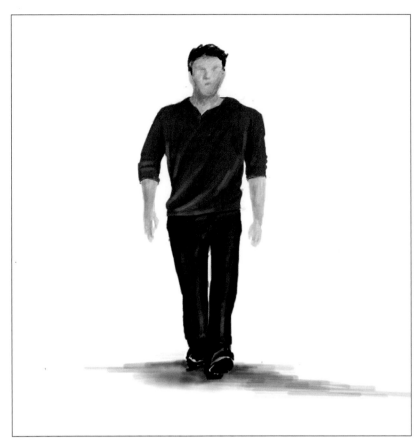

The finished figure

The amount of time you invest in a figure is up to you. Remember that for the purposes of including them in a landscape painting, figures can be kept very simple as they are not a focal point.

Other figures

Practise drawing figures and groups of figures. They can be saved as separate images and dropped in to landscapes to help add a spot of vibrant colour.

Buildings

Set up a new canvas and add black to your palette at full opacity.

You will need

Brushes: detail brush, eraser brush

Colours:

Black

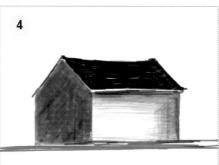

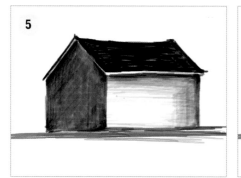

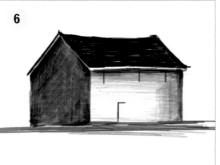

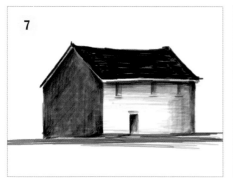

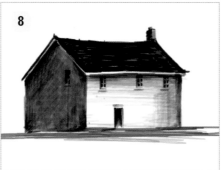

1 Use the detail brush to draw the gable end of a building with pure black at twenty-five per cent opacity.

2 Use the eraser brush to straighten and sharpen the edges by 'cutting in' – that is, working near to the shape so that you sharpen it with the edge of the eraser.

3 Change the detail brush's size to 5px and use black at fifty per cent opacity to draw out fine lines as shown with slow side-to-side strokes. Make sure the building walls are parallel with each other, and that the angles match on the roof. The shadow at the bottom can be looser than the structure of the house.

4 Reduce the opacity to five per cent and build up soft shadows on the large wall with horizontal strokes, then increase the opacity to seventy-five per cent and build up the colour on the roof in the same way. Leave a fine line of white showing at the base of the roof.

5 Lower the opacity to five per cent again and blend in the roof shadow. Overlay the structure's corners with black at fifty per cent opacity to strengthen the form, then blend these marks in with the opacity at fifteen per cent.

6 Using the black at fifty per cent opacity, add the shaded sides of the windows and doors.

7 Blend away from these lines with the black at ten per cent opacity, staying within the areas suggested by the initial lines. Use the same brush to add windowsills and a door lintel.

8 Add any final details such as the chimney and panes in the windows using black at seventy-five per cent opacity and a 2px brush size.

The finished building

Adding colour is simple with a glazing technique. Use the colours at ten per cent and gradually build up the hue on the walls and roof. The underlying black tones will remain visible and retain the shape of the building.

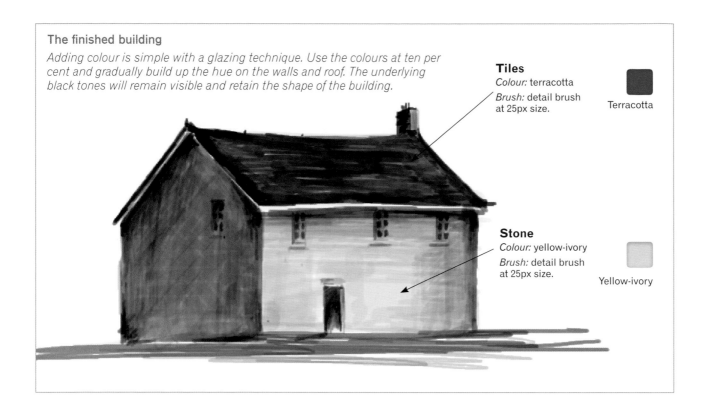

Tiles
Colour: terracotta
Brush: detail brush at 25px size.

Terracotta

Stone
Colour: yellow-ivory
Brush: detail brush at 25px size.

Yellow-ivory

Other example buildings

Buildings make fantastic additions to your landscape which give a sense of time and place to the finished painting. Try sketching out the basic shapes while you are outdoors, then colouring them later in the comfort of your studio or home.

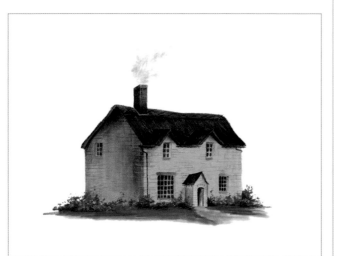

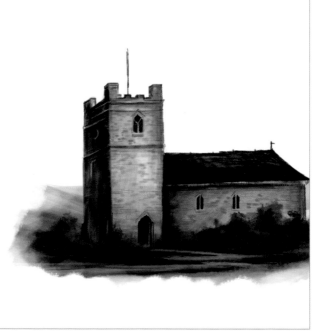

Layers

You can paint on your tablet in the same way as you would paint on a canvas or watercolour paper: starting with the background and working forward, adding the midground and the foreground details over the top in turn. You can simply work on a single layer, but using layers means you can work on separate sections of a painting – the sky, or hill, or figure, for example – without any danger of spoiling another part. Layers also help you experiment with the composition, even late into the painting process. You might decide to move the hills higher up in the scene to improve the composition, for example. Layers make this easy. You can even go into a layer and just delete that part of the picture without having to start the whole painting again.

The first layer is automatically in place when you start a new painting – to add another, open the layers palette and simply tap the + icon there.

Layer order

Layers are just like layers of clothing. Each one covers those below, so the only parts you see are those that remain uncovered by the ones on top.

In the example on this page, the complete painting is shown on the left-hand side, and the layers that make it up on the right. Layers nearer the top of the layers palette are in front of those below, so here layer 1 (at the bottom) is obscured by layers 2, 3 and 4.

The layers palette
The layers palette in Brushes *can be selected on the lower right of the screen. When you press the symbol, a menu will appear that displays all of the layers you have created.*

The layers palette

Layers allow you to do amazing things that would be difficult or impossible with watercolours or acrylic paints, like change the colour of selected parts of your painting or making specific areas more transparent. Layers can be a powerful tool – if you have painted a distant mountain, for example, lowering the layer opacity will cause more recession and alter the painting completely.

Layers also have blending modes, which allow you to give special effects to each layered section of a painting. They allow you to transform the separate layers, so if you paint a boat on a separate layer and later realise it is too small, you can enlarge or reduce it.

Merge
Pressing this symbol will merge the active layer with the layer below, combining them into a single layer.

Deleting layers
Press the dustbin/trashcan symbol to delete a layer.

New layers
Press the '+' symbol to create a new layer.

Visibility
Press the eye symbol to toggle whether the layer can be seen. A closed eye means the layer is hidden, temporarily removing it from the main painting. This is useful if you need to look at a layer on its own.

Duplicating layers
Press this to duplicate the active layer – very useful to quickly create multiple copies of an object, or to experiment with different colours while keeping the original layer safe.

Moving layers
You can alter which layers are in front of which using this symbol. Press it and drag the layer above or below others.

Locking
The padlock symbol allows you to lock or unlock a layer for editing. You can only paint on unlocked layers. Once you are happy with a layer, keep it locked to ensure you do not draw on it accidentally.

Layer number
This number simply indicates the order in which the layer was created – which is handy to help you keep track when you are moving layers around.

Active layer
The blue tone indicates the layer on which you are currently painting. If you find that you are painting and nothing appears, it may be that you are working on a layer hidden behind another.

Opacity
The opacity of a whole layer can be changed using the slider at the bottom of the menu, just like the colour menu (see page 32). This is great for pushing distant objects further away and lightening a sky.

Opening the layer palette
Pressing this symbol opens the layer palette.

Blending modes
Blending modes allow you to give special effects to each layered section of a painting. Most of the time you will simply use the 'normal' setting, but do play around with them and experiment to see what they do.

The only mode I commonly use other than 'normal' is 'multiply', which allows you to add objects (such as the ones on pages 50–57) to an existing painting. Normally, copying the object will bring the white background on which it was painted with it. Using the multiply blending mode will remove the background, leaving just the object.

How to use layers in a painting

Rather than trying to put everything on one layer, the painting here was created using a number of separate layers. The three main layers were painted relatively quickly to establish the main shapes and areas of the painting. Once the main layers are completed, it is a good idea to lock them so that you do not spoil them. Finishing layers are used mainly to refine the tones and details on a painting without risking the main areas. Note that the finishing layers shown opposite have a lot of overlap. By the end of the painting, there is no real need to make lots of layers; just enjoy painting.

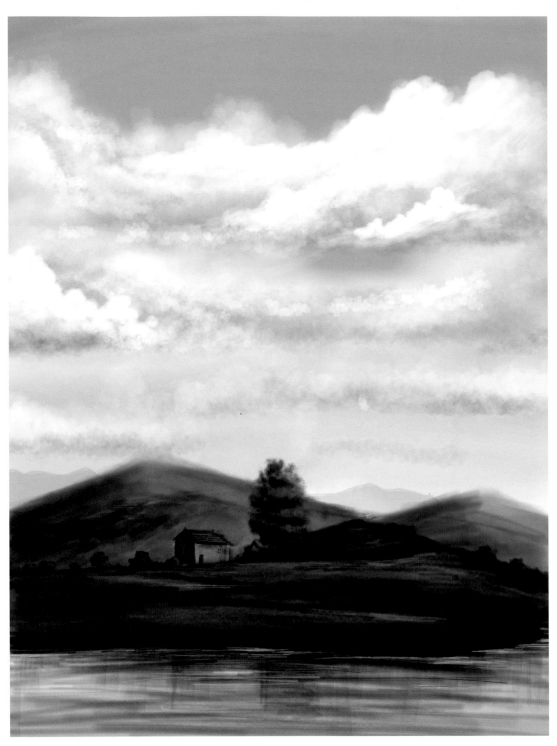

Lake Side

A peaceful scene, with a sky filled with fluffy, bubbly clouds. Featuring a single tree and reflections in the water at the bottom, this painting is a great example of how layers work in tablet art.

Main layers

Sky layer – 1

The sky layer was the first thing I worked on for this painting. Layers can be approached in any order, but it is sensible to work from the background to the foreground.

Water layer – 2

This foreground area includes water that uses the same blues as the sky layer, and also some of the greens in the land layer.

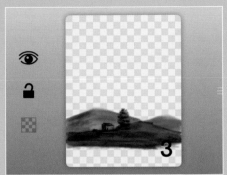

Land layer – 3

This contains most of the midground area. As well as the hills, there is a small building and tree to provide a focal point.

Finishing layers

Shadow layer – 4

This layer was used to build up the strength of tone in the hills and near the shoreline. Note the shading at the top, which helps to give the vignette effect and keep the eye in the picture.

Tip

Using the multiply blending mode when duplicating a layer (see page 59) can be useful for making multiple copies of an object – perfect for identical windows on a building, or trees in a background.

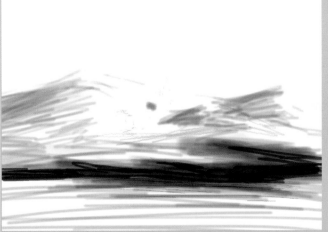

Detail layer –5

Containing additional shrubs, hedges and grassland detail, this layer is important to the final image.

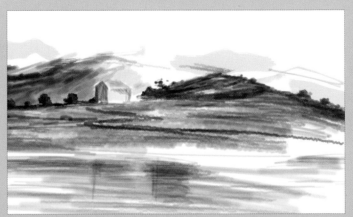

Transforming

Digital art has something that has no direct equivalent in traditional painting: the transformation controls. These allow you to alter various aspects of a painting, from the colour of a particular layer to the shape and size of objects. It is amazing how you can simply make an object in your painting bigger, something that is all but impossible with traditional watercolour painting.

The following pages look at how you can change your pictures for particular effects. For the colour and size adjustments, it is only the layer you work on that is altered, not the entire image. In the following examples the boat is on a separate layer from the sky, which allows you to transform the boat in isolation.

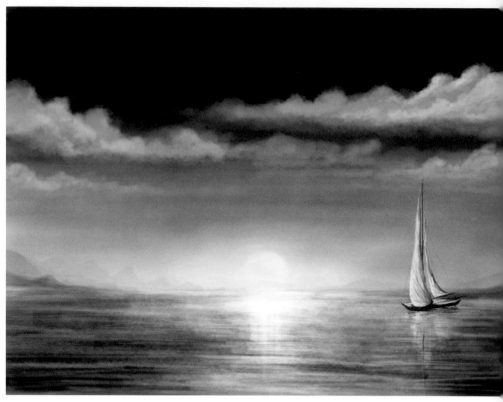

Sunset Lake
The original version of the painting shows a warm sunset over a lake. The sailboat forms a strong focal point.

Changing the colour

The following qualities of colour can all be altered in the same menu.

- **Hue** represents the inherent colour – the blueness of blue or redness of red. Changing the hue will alter a red shape to be blue (or green, and so forth).

- **Saturation** represents the purity or vividness of a colour. A desaturated colour will appear grey, while a super-saturated colour will be very vivid.

- **Brightness** is how brightly the colour appears on the image – a colour with no brightness will appear completely black, while an over-brightened colour will appear white.

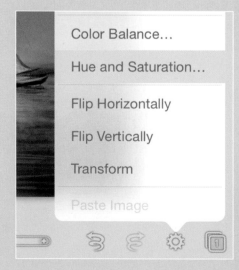

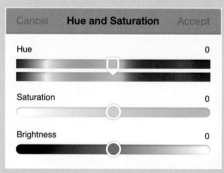

The hue and saturation box
Click on the cog symbol in the lower right of the screen, then press 'hue and saturation'. This brings up a box (above) with controls for these qualities of colour.

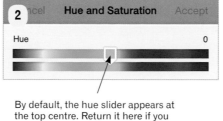

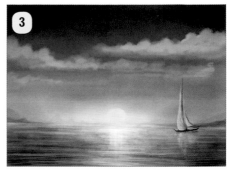

By default, the hue slider appears at the top centre. Return it here if you need to change things back.

Using the hue and saturation controls

1 Select the layer you want to alter – in this case, the sky. Remember that the active layer will be highlighted blue.

2 Open the hue and saturation box as described on the opposite page.

3 Move the slider to alter the hue. Here I have changed the sky from a deep purple to a moody blue. Note that the lower sky is unaffected. This is because it is on a different layer. Depending on the number of layers you have worked on, you may need to alter other layers to avoid odd effects.

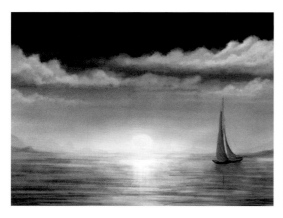

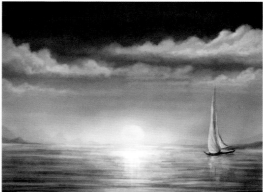

The left-hand image shows the original picture with the brightness of the sailboat reduced to create a silhouette effect. The right-hand image shows the original piece turned into a striking monochrome by reducing the saturation to nothing on all of the layers.

As the Sun Goes Down

By changing the hue of the sky, reducing the saturation in the sea and lowering the brightness of the boat, the mood of the painting is changed significantly, becoming calmer and more thoughtful.

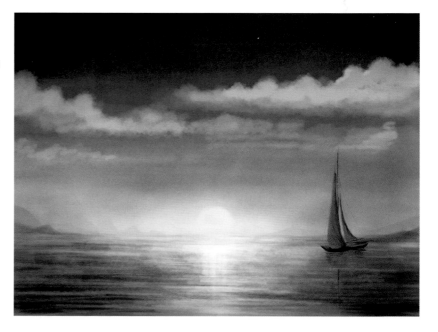

Transformation controls in other apps

All the art apps shown in this book have transformation options. In Brushes you tap the cog, while in Procreate you tap the magic wand to adjust the colour and the arrow to access the transform control.

Manipulating objects

In addition to adjusting the colour, you can transform objects – make them bigger or smaller, or rotate them. Perhaps you simply want to move the object. The essential thing here is that it is the layer you work on that is transformed, not the entire picture.

Using the transform controls

1 To begin, you need to select the layer you want to alter. In this case, it is the boat.

2 Press the cog symbol and select 'transform'. The layer can now be manipulated as though it were the whole canvas – see page 20.

3 Place two spread fingers on the surface.

4 Pinch them together to shrink the object.

5 Spread your fingers to expand the size of the object.

> **Tip**
>
> The instructions here focus on altering just one layer. You may, of course, want to adjust the whole picture. To do this, you have to either select all the layers at once or merge them together. Both processes can be done in the layers palette.

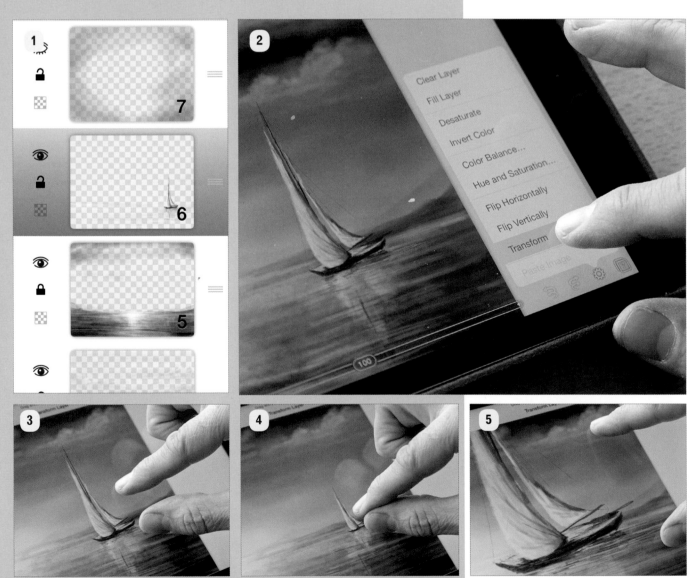

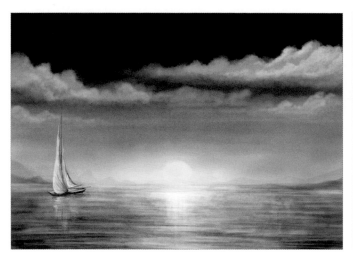

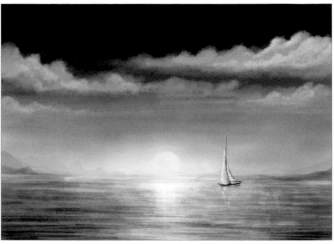

Moved

Moving the boat to one side alters the composition only subtly. Be aware of light direction when using this option. Here, the boat has been moved to the left of the sun, so the boat needs to be repainted with the highlights towards the sun. Alternatively, you could simply use the 'flip horizontally' option from the transform controls (see opposite).

Reduced

Making the boat smaller reduces its importance in the picture, moving the focus to the rest of the landscape. When moving objects into the distance, you can make the object bluer and desaturate it slightly to increase the sense of perspective and distance.

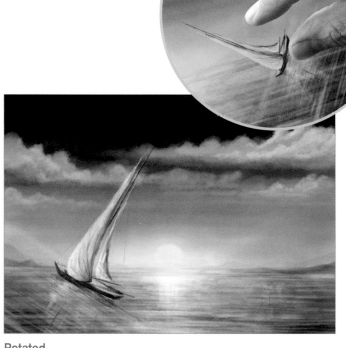

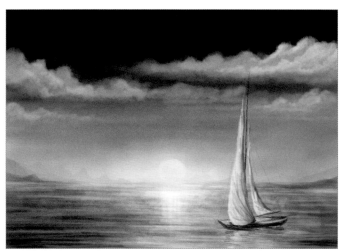

Enlarged

A simple enlargement is a common task for me. I often find an object I am painting – whether a building or a tree – is a little on the small side. Using the transformation controls, I can simply select the relevant layer and enlarge by spreading two fingers apart on the tablet surface.

Rotated

As well as simply moving or changing the size of the object, you can rotate the object with a twisting motion of your fingers (see inset). While this effect might not be particularly appropriate for this boat, the option is there for you to experiment with.

Using your tablet

Your tablet is a great portable tool that can help you find ideas for composition in your paintings. As well as a camera, the iPad I use has various tools for editing photographs, so I can crop the image to improve the composition. Most art apps also allow you to take the colour from the photograph you have taken. This give you precise colour selection.

Using the camera

A walk around the countryside or local park is likely to provide inspiration and ideas for landscape painting. Most tablets include a digital camera, and taking pictures can help you quickly evaluate whether there is potential in the scene.

1 Head outdoors and look for scenery that you find attractive. You often don't have to go far – many local parks or even large gardens have great potential.

2 Hold the tablet so the screen is in a landscape format and use the camera on your tablet to frame up a potential landscape.

3 Take plenty of shots from many angles, and some of the surrounding area. This is to get lots of additional detail in case you find something missing from your main shot.

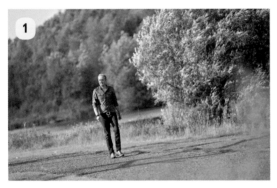

Composition

While the camera will take accurate pictures, it can't operate like a human imagination, so you will have to compose the painting yourself. You will naturally do this when you take the photograph – some things just 'look right', but spending a few minutes looking at your pictures and tweaking them can help make them something really special.

Some things are obvious – you might want to crop out (or simply leave out) parts you find unattractive, like litter bins.

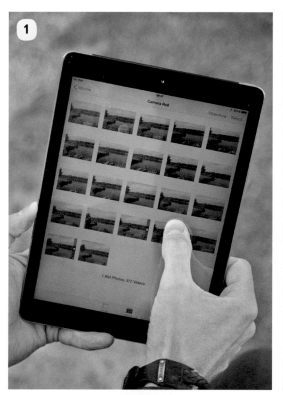

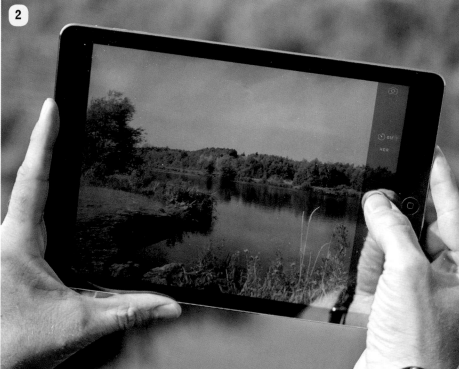

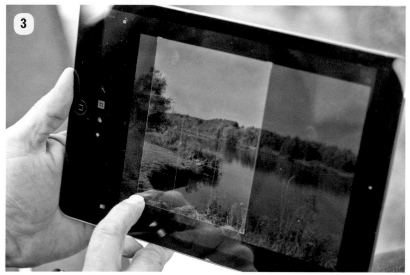

1 Find somewhere comfortable to sit and look through the photographs you have taken.

2 Seeing the image on-screen will let you see whether the scene will work as a painting.

3 You may find one of your pictures is perfect as it is, but feel free to alter them. Most tablets include some basic editing tools, such as cropping, which allows you to turn a landscape format picture into a portrait format, as shown here using the built-in 'edit' function common to almost all tablets.

Sketching with your tablet

One great advantage of the tablet is that you have everything you need with you to sketch in the field. No need to carry around lots of equipment – as long as you have your tablet and stylus, you can paint anywhere. Sketching outside is a real pleasure, especially if the weather is warm and comfortable.

Aim to finish each sketch in just a few minutes, and move on. To help with speed I suggest using a sketching brush (see right), which simulates the texture of charcoal. This will keep things loose, and gives a different effect to more detailed work.

New brush: Sketching brush

This brush acts a little like a pencil or a piece of charcoal, and is fantastic for quickly creating interesting black and white sketches.

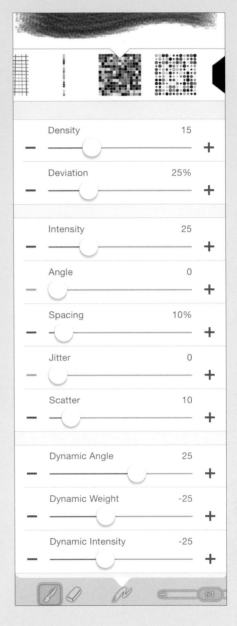

Density	15
Deviation	25%
Intensity	25
Angle	0
Spacing	10%
Jitter	0
Scatter	10
Dynamic Angle	25
Dynamic Weight	-25
Dynamic Intensity	-25

Differences from the default round brush:
Size: 15px
Density: 15
Deviation: 25%
Intensity: 25
Spacing: 10%
Scatter: 10
Dynamic angle: 25
Dynamic weight: –25
Dynamic intensity: –25

1 Find somewhere comfortable to sit near the landscape you want to sketch, then set up a new picture (see page 16). Select the sketching brush (see above).

2 Using the stylus as a pencil, begin to sketch in the basic shapes. Just use grey tones to keep things simple and quick.

3 Aim to complete the sketch in around ten minutes – these are not full paintings, so make the most of your time outdoors by making more than one.

Sketch at Poolsbrook Park

The sketch below was completed in ten minutes or so at Poolsbrook Park, a picturesque recreation ground close to where I live in Derbyshire, UK. The two images to the left show earlier stages in the same sketch. Concentrate on getting the important information in early – just in case the weather worsens or you have to leave unexpectedly.

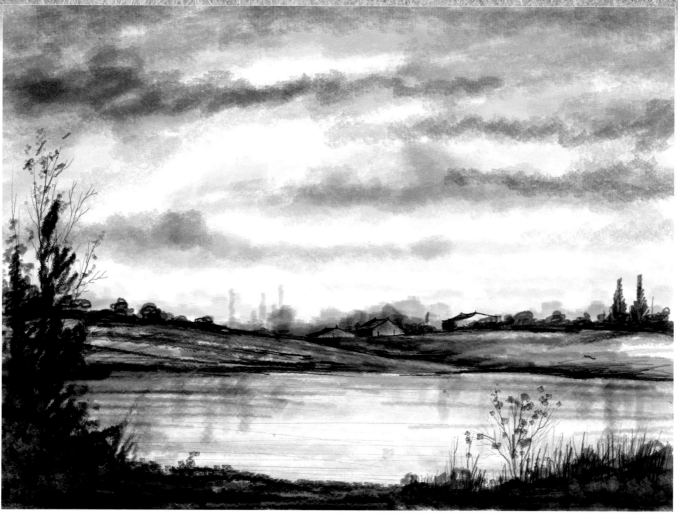

Using photographs

Using a photograph you have taken as the basis for your painting can help you when you are starting out. The photograph can be imported into your app on a separate layer; which allows you to simply paint over the top of it. The photograph layer can then be deleted or hidden to leave just your finished artwork. This is good practice for painting your own landscape compositions.

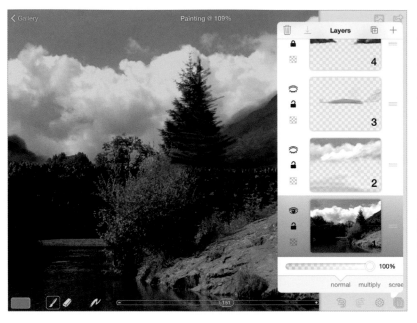

Importing photographs

You can import photographs into some apps. In *Brushes*, you simply tap the 'import' button at the top right-hand corner. This will take you to your photo library. Once you pick a photograph, it will be inserted into the app on its own layer.

Importing photographs into other apps

The exact method of importing a photograph will vary from app to app. In Procreate, *press the spanner icon at the top left, then click 'insert' to import a photograph.*

Picking colours

Pressing and holding your finger over a particular colour will select that colour. Notice how a ring appears (see right, top) in the colour you are touching. Moving your finger around will change the colour, and lifting it away from the screen will select the last colour touched.

This is a great way to build up your palette from a photograph, particularly if you are not so confident in creating colours; and useful if you simply want to double check.

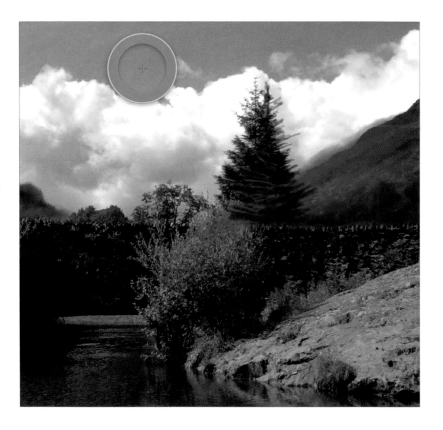

Castle

Not far from where I live in Derbyshire is this imposing castle, which makes a wonderful skyline detail in a landscape painting. Of more importance to the composition are the bands of colour formed by the landscape. This is a good example of using the photograph as inspiration rather than directly painting over the top of it, as described on the opposite page.

Here, I started with a simple sky before adding the unusual yellow-brown stubble in the foreground. The castle was added between the two to add shape and interest to the background (see right), and then the trees and foreground grasses were added. To finish, I added some wispy clouds and further detail across the painting.

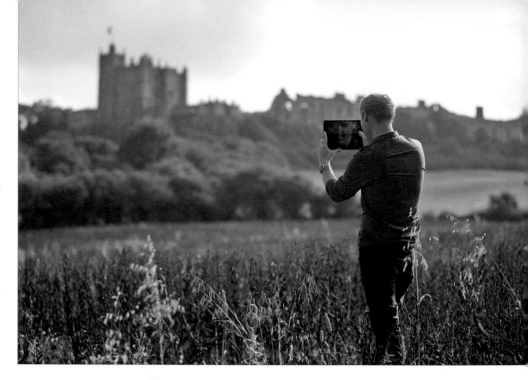

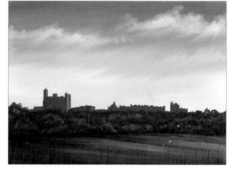

The finished painting.

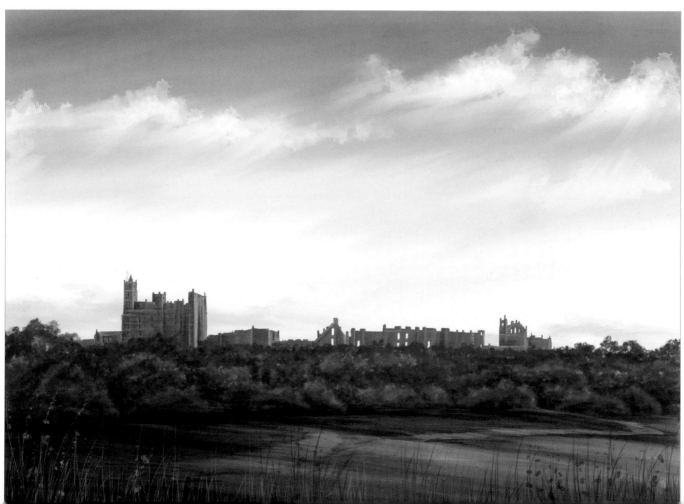

Reflections at Cuckney Mill

This mill is in Nottinghamshire, UK, and is a very peaceful place. As a result, and because there is so much useful inspiration, it is a favourite spot of mine to sit and paint.

Because of the large mill pond, you can often see the mill building reflected in the water.

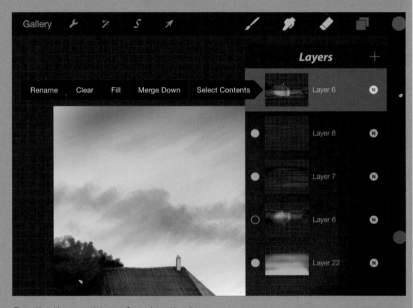

Duplicating and transforming the layer.

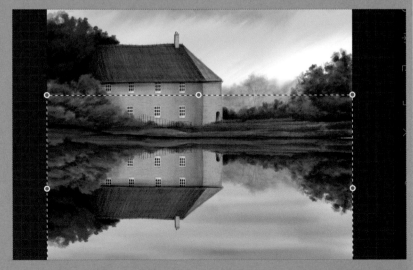

The reflection in place, just prior to smudging.

The smudge tool

Smudging

This painting was made in *Procreate*, which made it very simple to create a convincing reflection. Once the basic painting was completed, the layer with the building was duplicated in the layer menu, then the duplicate layer was flipped vertically with the transform tools and moved into place.

With the reflection in the right position, I then used a tool only present in *Procreate* – the smudge tool. The smudge tool causes the paint to smear following your finger or stylus. With the opacity of a large wash style brush set to fifty per cent, I applied gentle downward strokes to the reflection area, gradually drawing down the colour and blurring the shape to create a convincing reflection in the water.

Opposite:
The finished painting.

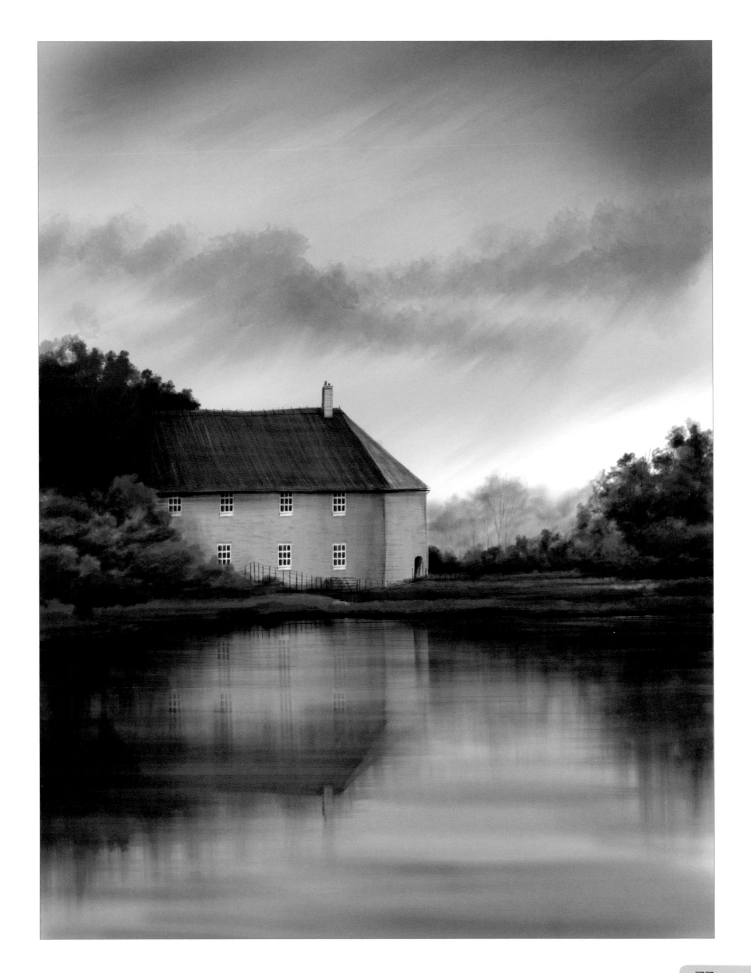

The paintings

The next section of this book builds on the simple exercises earlier and walks you through four step-by-step landscape paintings that combine all the techniques featured in the previous chapters. By the end of this part of the book, you will have practised everything you need to paint your own landscape paintings on your tablet. Of course, you should feel free to adapt the paintings using the skills you have learned. Once you have finished, why not try adding a building or a tree; or changing the season or time of day?

All the paintings are produced on an iPad Air using a brush stylus and the current version of *Brushes (Brushes Redux)*, but the instructions can be adapted to any art app or tablet you prefer to use.

Video tips

For a little extra help with these paintings, download a QR reader to your tablet and scan this quick response code to be directed to the website of the SAA, Society for All Artists.

Here you will find videos in which I show you some more handy hints and tips on painting with your tablet.

If you do not wish to download a QR reader, you can enter this address into your web browser to get to the same page:
www.saa.co.uk/no-paint

How the instructions work

Each painting is broken down into stages, with notes on what to do in each area, as shown below. In order to makes things as clear as possible, these notes are colour-coded so you can see at a glance what layer you should be working on for that part of the painting. Small swatches of the colours you need are also provided at each stage, so you can copy them as you go.

New colours

■ Light blue

■ Dark blue

■ Mid-grey

Layers

1 Sky **2 Land**

Instruction boxes

Information on what to do in the indicated area will appear here. The border colour shows what layer you should work on. In this case, the colour indicates layer 1, which is the 'sky' layer (see above).

Colour: This part will tell you what colour (or colours) to use, and at what opacity.

Brush: This part tells you what brush to use from those described on pages 27–30. If there are any modifications to the brush, such as a different size, that information will also appear here.

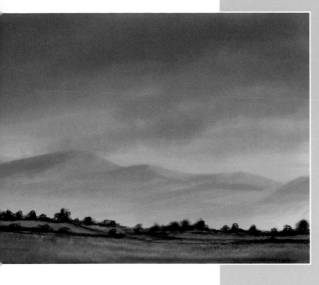

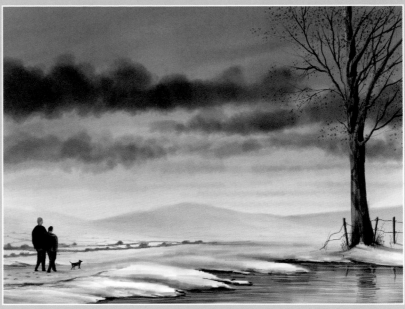

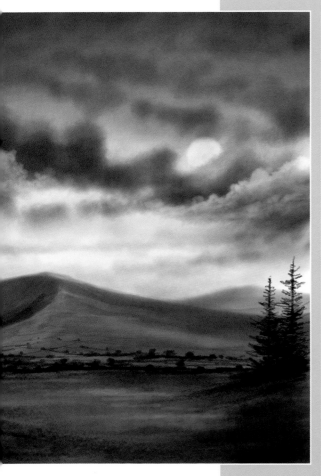

View over the Hills

This simple landscape is a great starting point for your painting. It builds directly on the earlier exercises while going into much more detail about each stage of the painting. It will lead you nicely into the following landscape paintings.

Basic sky
The base layer of the sky (shown above) is a light blue which fades away to nothing.
Colour: light blue at full opacity at the top; blended down to ten per cent opacity at the bottom.
Brush: large wash brush.

Stage 1: Background

Create two layers, and build up a basic sky on the first layer. Use light blue first and fade it away towards the bottom as described on pages 34–35, then build up the tone with dark grey in the top corners.

With the sky complete, change to the second layer and paint in some hills using mid-grey. Use the mid-grey at full opacity at this point, as it is easier to knock colours back later than strengthen them.

Hills
Use smooth strokes and do not extend the hills much past a third of the way up the painting from the bottom. Smooth the shapes out with rounded strokes to create the sense of rolling hills.
Colour: mid-grey at full opacity.
Brush: small wash brush.

New colours

- Light blue
- Dark blue
- Mid-grey

Layers

1 **Sky**
2 **Land**

Dark corners
Add dark blue areas in the corners and blend them into the sky.

Colour: dark blue at ten per cent opacity.

Brush: large wash brush.

Options
Experiment with the shape of the hills. The sharper hills shown to the left would work well for a more mountainous painting.

Stage 2: Foreground

With the sky and land in place, we now add a third layer. The addition of a grassy area in the foreground will be used to create a vignette effect to draw the viewer into the picture.

Adding shading to the hills at this stage begins to create a sense of weight and shape, while the bright green at the bottom of the new grassy area helps to create depth in the picture.

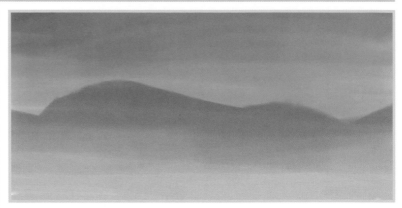

Hills
Knock back the hills by selecting layer 2 and reduce the opacity until you can see the bottom part of the sky behind it. This creates a sense of misty recession and perspective.

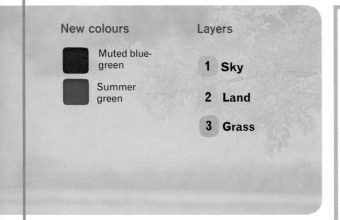

New colours	Layers
■ Muted blue-green	**1 Sky**
■ Summer green	**2 Land**
	3 Grass

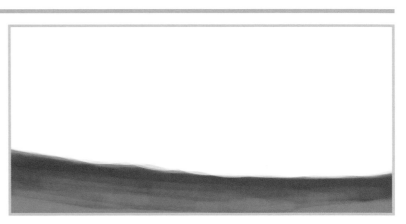

Vignette effect
When adding the grass, make the sides slightly higher than the centre. You can see this clearly in the isolated layer image above.

Together with the dark corners of the sky, these areas create a vignette effect, where there are strong, dark tones in the corners which creates a 'frame' to help keep the viewer's eye within the painting.

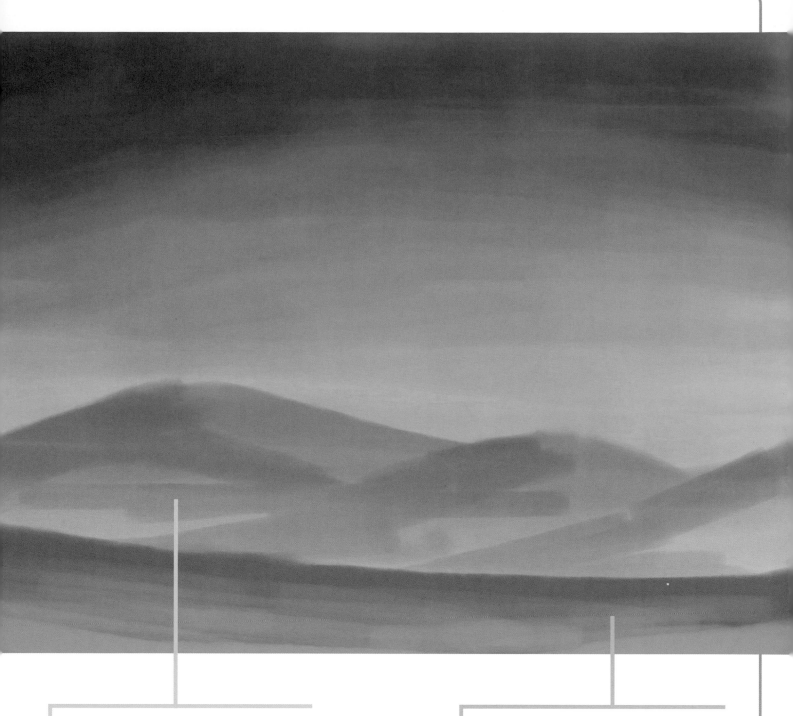

Hill shading
Keep the shading on the left-hand sides of the hills.

Colour: mid-grey at fifteen per cent opacity.

Brush: small wash brush with the size set to 50px.

Foreground grass
Colour: Use muted blue-green at full opacity at the top of the grass area to add depth. Blend it into summer green, at twenty-five per cent opacity, at the bottom.

Brush: small wash brush.

Stage 3: Adding texture

The hedges are all made by dragging the stylus brush along, but the direction of the brushstrokes varies with how distant they are. All of the hedges are restricted to the top half of the grassy area. This is because the lowest part of the painting should stay relatively clear to suggest distance.

The cloud brush is good for creating texture and suggesting distant foliage because it is fairly loose and gives a semi-random effect.

New colours

Light blue-grey

Forest green

Layers

1 **Sky**

2 **Land**

3 **Grass**

4 **Foliage and texture**

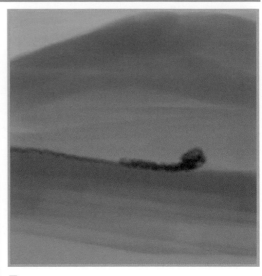

Trees
Occasional larger trees add interest and a sense of scale to the hedgerows. They can be made with the same brush and colour as the hedgerows (see below). Simply use small twisting gestures with the stylus to make them. More distant trees should be smaller than those close-to.

Additional hills
Adding distant hills between the original hills develops more depth in the painting. It also gives the horizon a more realistic shape.

Use the same brushes, colours and techniques as in stages 1 and 2, but make the edges slightly less distinct and the colours slightly less opaque to suggest distance.

Overview of the stage
It can be quite difficult to see the subtle textures built up with the cloud brush and semi-transparent colours at this stage. This detail of the new foliage layer shows the sort of result you want at the end of this stage.

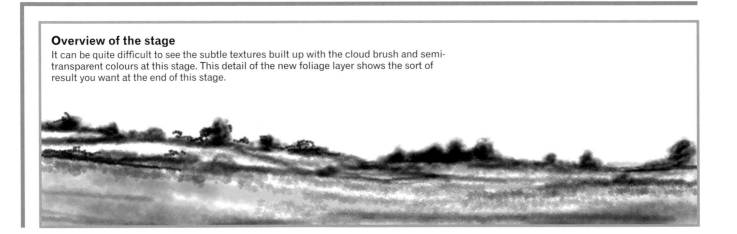

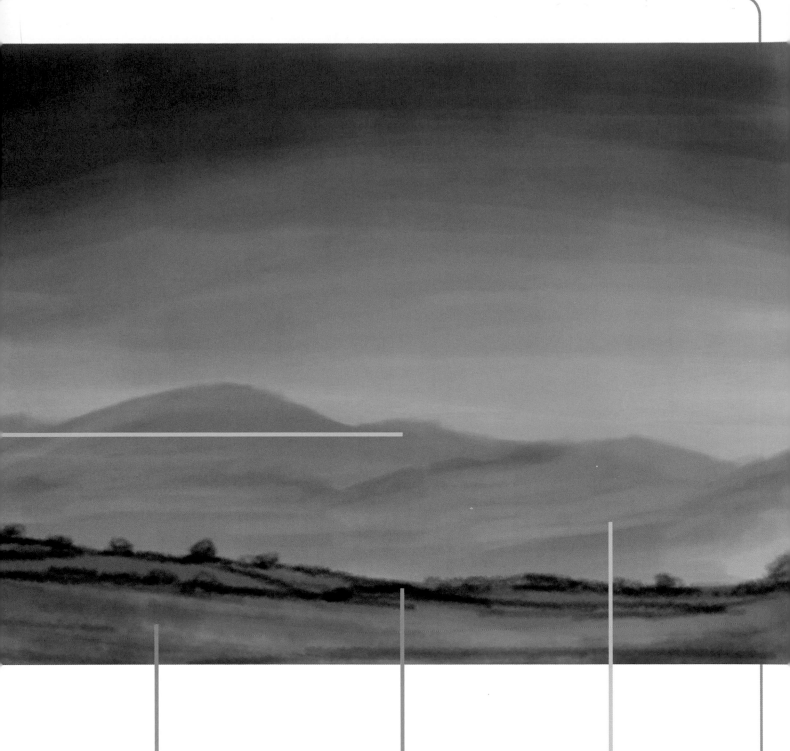

Foreground texture
Skim over the foreground with horizontal strokes of the finger, building up the texture to suggest grass.

Colour: forest green at ten per cent opacity.

Brush: cloud brush at 100px.

Hedgerows
Use long unbroken strokes, parallel to the horizon line, to establish a few main hedgerows. Change to shorter diagonal strokes to join the main hedgerows together and suggest fields. Alter the brush size as you work to avoid an unnatural uniform appearance.

Colour: forest green at fifty per cent opacity.

Brush: cloud brush between 15–20px size.

Hill highlights
Adding highlights to the hills allows you to refine their shapes and start making them look more realistic.

Colour: light blue-grey at fifty per cent opacity.

Brush: small wash brush at 50px.

Stage 4: Refinement

The basic shapes are all in place from the previous stage. Now is the time to look at the painting as a whole, and see what changes and refinements can be made to improve the overall picture.

In particular, more subtle tones and textures are added to both the sky and the foliage in order to build detail and interest across the painting.

New colours

■ Green-black

Layers

1 Sky

2 Land

3 Grass

4 Foliage and texture

Refine the sky

Adding the suggestion of faint clouds with the cloud brush gives a more interesting effect to the sky and helps balance the more detailed ground.

Colour: dark blue and mid-grey at fifteen per cent opacity.

Brush: cloud brush with the size set to 300px.

Darken the mountains

Deepening the shadows with a finer brush reinforces the form. Be careful to keep the shadows mainly on the left-hand sides of the mountains.

Colour: mid-grey at fifteen per cent opacity.

Brush: small wash brush with the size set to 25px.

Checking colours

If you are unsure what colour you have used in an area, press and hold your finger on the area until a ring appears (see above). This will sample the colour at the point you are touching, so you can start painting with it straight away.

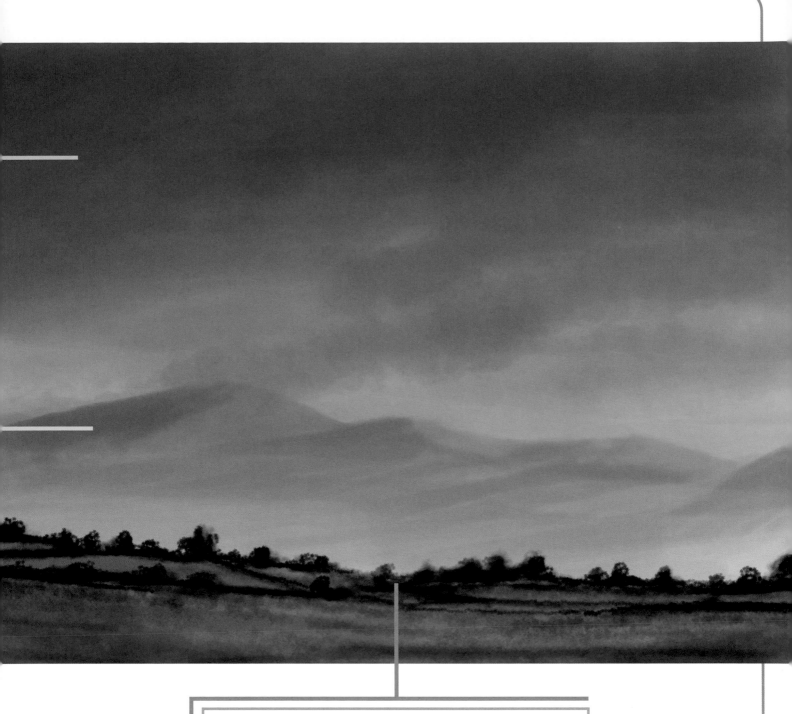

Additional trees

These especially dark trees are placed to draw the eye to the focal point. Note that I added the trees on the grass layer (see above) rather than the foliage layer. This was accidental, as I was caught up in the work and forgot to change layers. This is not a problem. Towards the end of a painting, it is less important to work on the 'correct' layer than earlier.

Colour: green-black at fifty per cent opacity.

Brush: cloud brush at 15px size.

Stage 5: Adding final details

The final stage is concerned with sharpening and refining the image through making small adjustments. This is where the tablet shines, allowing you to go back to previous layers.

Layers

The final appearance of the layers at the end of the painting.

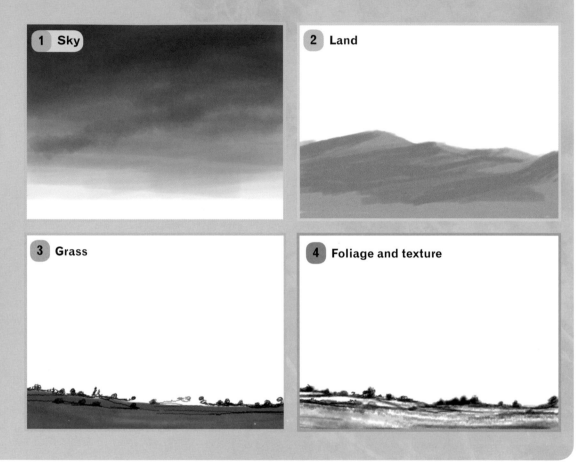

1 **Sky**

2 **Land**

3 **Grass**

4 **Foliage and texture**

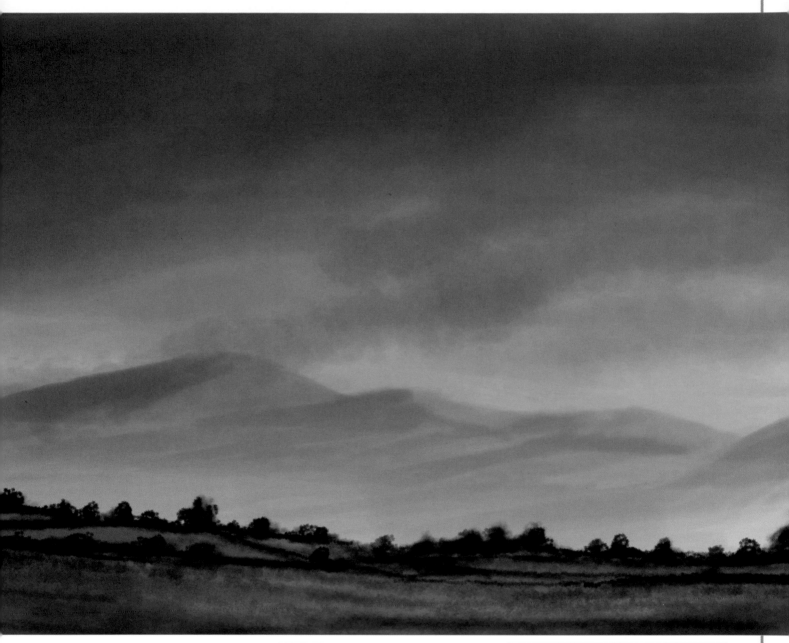

The finished painting.

Foreground texture

Use your finger to skim over the foreground grass to create more detail and depth to the finished painting.

Colour: summer green at seventy-five per cent opacity.

Brush: texture brush at size 50px.

Darkest tones

Some very dark tones added to the foreground trees, along with a couple of additional hedgerows, help to draw the eye to the focal point of the painting.

Colour: green-black at full opacity.

Brush: cloud brush at size 15px.

Moonlit Night

This moody painting will teach you how to create atmosphere in your skies and paint realistic pine trees. The transform and layer controls are also used to good effect here to add the misty moonlight – as well as the moon itself.

Clouds
Build up the clouds until the tone is quite dark, especially in the central cloud bank.
Colour: dark blue-grey at twenty-five per cent opacity.
Brush: cloud brush ranging between 150 and 200px size.

Stage 1: Sky, clouds and ground

This stage lays the groundwork for the painting, creating a misty, distant feel through transparent ground and rain. The mountains and clouds add tonal contrast.

Reducing the hardness of the brush for the distant mountain helps create the sense of distance, too.

New colours

▪	Teal
▪	Blue-grey
▪	Pale cream
▪	Off-black

Layers

1 **Sky and initial ground**

2 **Cloud highlights**

3 **Hills**

Cloud highlights
Use a wiggling/twisting motion to apply these highlights. Blend them into the sky with touches of less opaque colour.
Colour: pale cream ranging between five and twenty-five per cent opacity.
Brush: cloud brush at 50px size.

Distant rain
With the sky in place, darken the top of the painting area with dark blue-grey, then add rain emerging from the dark area using diagonal strokes of the brush.
Colour: dark blue-grey at fifteen per cent opacity.
Brush: cloud brush.

Basic sky
See pages 34–37 for information on how to paint a basic sky.
Colour: teal at full opacity at the top, blended down to ten per cent opacity at the bottom.
Brush: large wash brush.

Initial ground
Build this up with horizontal strokes to achieve a misty, transparent appearance. Start from the bottom as shown.
Colour: blue-grey at five per cent opacity.
Brush: small wash brush at 150px size.

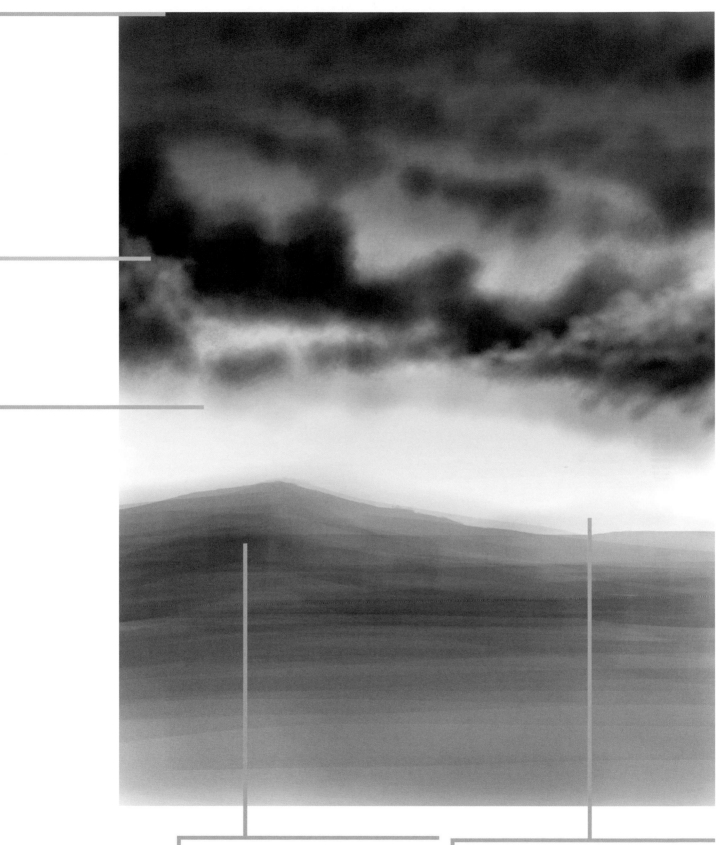

Foreground mountain

Build this on top of the initial ground (see left).

Colour: pale cream ranging between five and twenty-five per cent opacity.

Brush: cloud brush at 50px size.

Distant mountain

Colour: pale cream ranging between five and twenty-five per cent opacity.

Brush: small wash brush with hardness altered to 0.

Stage 2: Tonal work

This stage is mainly concerned with the mountains. We darken them, then add highlights, and finally extend them into a grass-covered foreground meadow.

 With those complete for the moment, we also add a foreground field at this stage. The tonal work here is darkening the corners and adding subtle texture with horizontal strokes.

New colours

■ Mid-green

■ Dark green

Layers

1 Sky and initial ground

2 Cloud highlights

3 Hills

4 Foreground grass

Dark corners

Add dark blue areas in the corners and blend them into the sky.

Colour: dark blue at ten per cent opacity at the bottom.

Brush: large wash brush.

Dark tone

Darken the top of the larger mountain to differentiate it from the more distant one and push it away. Blend the tone away towards the bottom of the painting area.

Colour: blue-grey at full opacity at the top, and ten per cent opacity at the bottom.

Brush: small wash brush at 150px.

Foreground

Build up the foreground over the top of the base of the hills so that the underlying hill layer blends into the grass.

Colour: dark green at twenty-five per cent opacity at the base of the hills, then mid-green at fifty per cent opacity down to the bottom.

Brush: large wash brush at 150px size.

Highlights

The highlights are worked in three stages; the first to give the main structure:

Colour: pale cream at ten per cent opacity.

Brush: small wash brush at 150px.

The second stage is worked to sharpen the top of the ridge only:

Colour: pale cream at ten per cent opacity.

Brush: small wash brush at 10px.

The third stage adds smaller, softer highlights lower down the hill:

Colour: pale cream at ten per cent opacity.

Brush: small wash brush at 25px.

Horizon line

Build up a stronger tone on the horizon to define the edge of the meadow.

Colour: dark green at twenty-five per cent opacity.

Brush: large wash brush at 25px size.

Bottom corners

Create a vignette effect to draw the eye to the centre by blending the darker colour over the mid-green at the sides.

Colour: dark green at twenty-five per cent opacity.

Brush: large wash brush at 150px size.

Stage 3: Foliage

The foliage is important in adding a sense of proportion and scale, from the large and fairly detailed pine trees in the foreground, to the midground hedgerows, and the faint suggestion of field boundaries further up the distant mountain.

The pine trees can be painted with the midground foliage brush, but a specific brush to give a harder, denser effect works better.

New brush: Pine tree brush

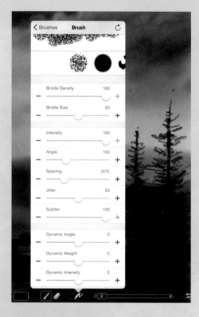

Differences from the default round brush:

Size: 8px *Angle: 100*

Bristle density: 100 *Spacing: 50%*

Bristle size: 50 *Jitter: 50*

Intensity: 100 *Scatter: 100*

New colours Layers

Light green

1 **Sky and initial ground**

2 **Cloud highlights**

3 **Hills**

4 **Foreground grass**

5 **Foliage**

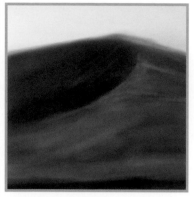

Initial hill glazing
Build up subtle overlaying highlights on the hill to blend the foreground into the lower part of the hill.

Colour: light green at ten per cent opacity.

Brush: large wash brush at 100px.

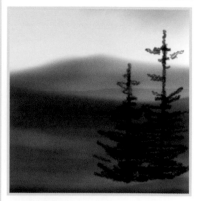

Pine trees
Start by drawing vertical lines for the trunks of the trees, then add lines coming up and away from the trunk at an angle. Start with fairly long branches at the bottom and taper away the length as you work towards the top.

Colour: off-black at fifty per cent opacity.

Brush: pine tree brush.

Hillside hedges
Colour: dark green at fifty per cent opacity.

Brush: cloud brush at 2px.

Midground hedges
Add these in the same way as the foreground hedges (see opposite), but using smaller motions for a tighter effect.

Colour: dark green at seventy-five per cent opacity.

Brush: cloud brush at 4px.

Meadow highlights
Restrict the highlights to the centre to keep the edges dark. Use horizontal strokes.

Colour: light green at twenty-five per cent opacity.

Brush: texture brush with scatter altered to 100.

Dark texture
Build up the marks slowly to strengthen the dark tone in the corners.

Colour: dark green at twenty-five per cent opacity.

Brush: texture brush at 100px.

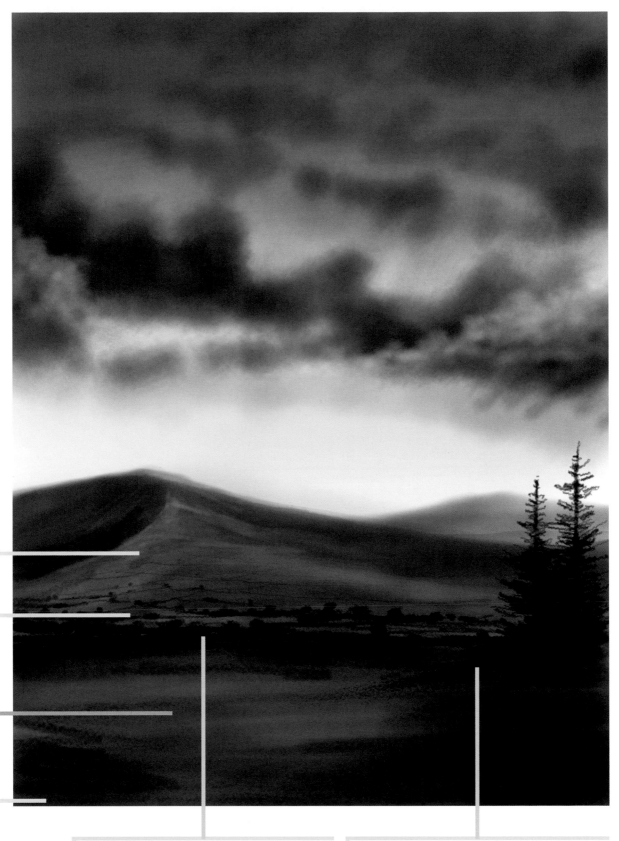

Foreground hedges
Add two or three horizontal rows with circling motions, with occasional larger spirals for trees.

Colour: dark green at full opacity.

Brush: cloud brush at 15px.

Tree shadow
Add the shadow beneath the trees, and also in the centre of the mass.

Colour: off-black at fifty per cent opacity.

Brush: pine tree brush.

Stage 4: Atmosphere

The moon is an important part of this landscape as it provides a focal point and also casts light over the rest of the picture. As it is on a new layer, you can use the transform controls (see pages 62–65) to experiment with the placement of the moon before you make your final decision. Do this before beginning the other parts of this stage, as they will depend on where the moon sits.

Most of the additional painting for atmosphere occurs on the same layer as the moon itself. This is because it makes it much easier to adjust things together. For example, because the highlights in the cloud and meadow are on the same layer as the moon, if you decided to dim the moon by altering the brightness, the other light it casts will dim at the same rate – much faster than having to repaint or alter many separate layers.

Layers

1. **Sky and initial ground**
2. **Cloud highlights**
3. **Hills**
4. **Foreground grass**
5. **Foliage**
6. **Moon**

Foreground cloud highlights
Reinforce existing highlights where the moon is shining on them. Strengthen the colour further from the moon itself slightly less.

Colour: blue-grey at twenty-five per cent opacity.

Brush: cloud brush ranging between 150 and 200px size.

Additional clouds
Some subtle horizontal strokes add a sense of distance and mystery to the painting.

Colour: blue-grey at fifteen per cent opacity.

Brush: cloud brush at 50px size.

Initial moon
Use a circular motion to create a simple moon. An enlarged version of the detail brush is used so the resulting shape has a hard edge.

Colour: pale cream at full opacity.

Brush: detail brush at 50px size.

Developing the moon
Switch to the eraser (see page 25) and cut away the bottom right-hand part of the moon in the shape of the cloud in front of it.

Colour: none.

Brush: cloud brush at 25px size and eraser tip.

Next, add some subtle texture to the surface

Colour: blue-grey at fifty per cent opacity.

Brush: cloud brush at 25px size.

Meadow highlights
Keep these subtle but make them stronger directly below the moon. Use horizontal strokes that follow the contours of the ground and sweep up slightly at the sides of the painting.

Colour: light green at twenty-five per cent opacity.

Brush: texture brush at 75px size, with scatter altered to 100.

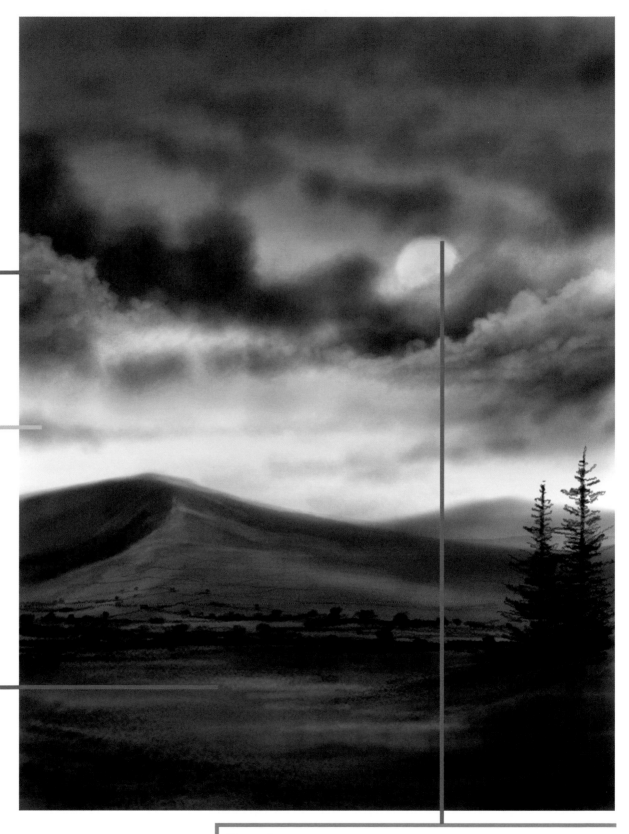

Moon glow

Knock the layer transparency to fifty per cent to reduce the brightness of all the light and give a more subtle feel. Give the moon a hazy halo by circling the edge until the hard edge is hidden. Zoom in for more control.

Colour: pale cream at seventy-five per cent opacity.

Brush: detail brush at 50px size, with hardness and intensity both reduced to 0.

Stage 5: Finishing

A final layer is added here to create a warming pink glow to the centre of the painting. The layer is then moved behind the foreground layers so that it sits correctly in the sky.

This layer is optional – try turning the visibility of the layer on or off (see page 59) to see which you prefer. You might also try altering the transparency of the layer to strengthen the glow or make it more subtle. It is your painting, so feel free to make your own decisions.

Pink glow

Create the layer and use large horizontal strokes that build behind the mountains up towards the sky. Once complete, move the whole layer between layers 1 and 2, so that the pink glow appears behind the mountains.
Colour: sky pink at five per cent opacity.
Brush: large wash brush.

Darken the corners

Build up the tone in the upper corners.
Colour: blue-grey at five per cent opacity.
Brush: large wash brush.

The finished painting.

New colours

Sky pink

Layers

1 **Sky and initial ground**

2 **Cloud highlights**

3 **Hills**

4 **Foreground grass**

5 **Foliage**

6 **Moon**

7 **Pink glow**

Sky layers

The appearance of the sky layers at the end of the painting. The pink glow layer is moved to sit between layers 1 and 2, as shown to the right. Note that this will reorder the numbering on screen.

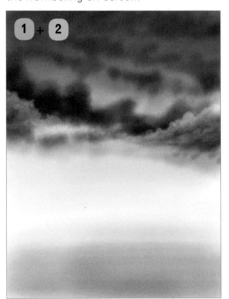

1 + 2

7 Pink glow

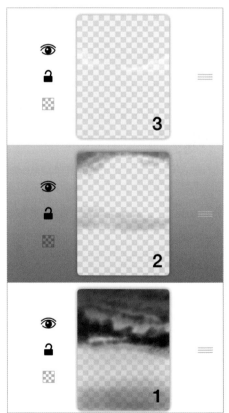

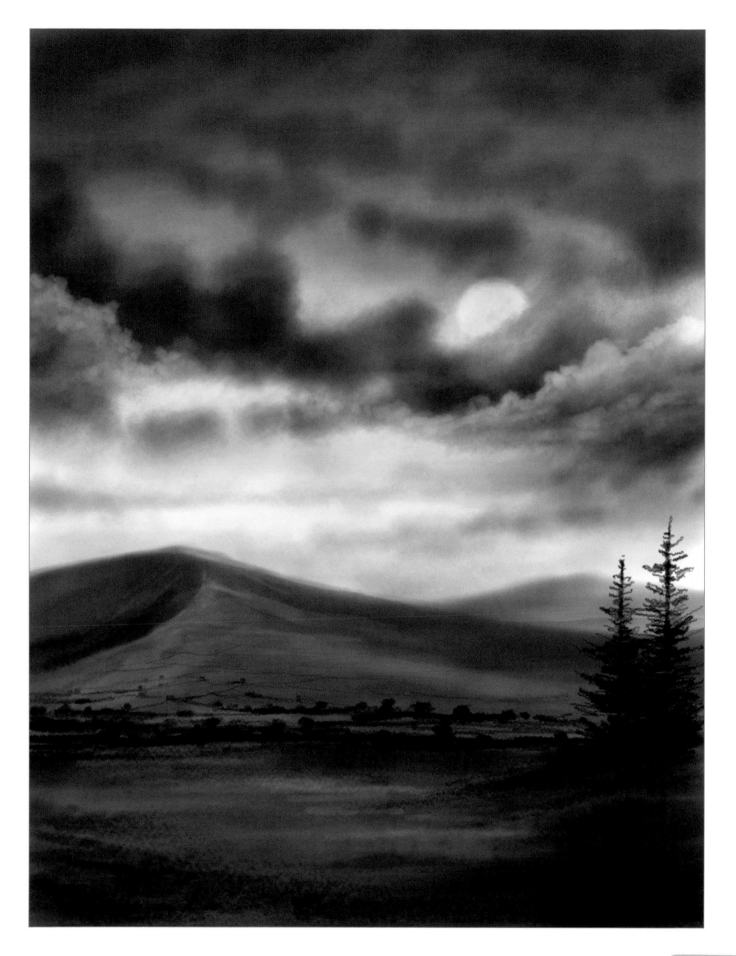

On a Winter's Day

This project will show you how to approach water and reflections, how to add figures and integrate them into your landscapes – oh, and snow!

In this painting, you will be adding more detail work, working with shadows and painting two people walking a dog, leaving their footprints behind.

Stage 1: Background

Create three layers. Using the colours below, build up a basic sky as described on pages 34–37, then build up the tone with dark grey in the top corners.

The snow-covered hills start as dark blue-grey silhouettes, with a lighter tone layered on top. Note that the snow grey and snow white, while both light in tone, are not pure white.

New colours

- Evening blue
- Sunset yellow
- Dark blue-grey
- Cloud grey
- Snow grey
- Snow white

Layers

1 **Sky background**
2 **Clouds**
3 **Land**

Basic sky
Start at the top and blend the blue into yellow towards the horizon. Add a little dark blue-grey in the corners.
Colour: evening blue at full opacity, sunset yellow at twenty-five per cent opacity, blending away to ten per cent. Dark blue-grey at ten per cent.
Brush: large wash brush.

Dark clouds
The darkest clouds are at the top of the picture.
Colour: cloud grey at seventy-five per cent opacity.
Brush: cloud brush at 200px size.

Lighter clouds
Start at the top and blend the blue into yellow towards the horizon. Add a little dark blue-grey in the corners.
Colour: cloud grey at fifty per cent opacity.
Brush: cloud brush at 100px size.

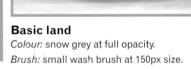

Basic land
Colour: snow grey at full opacity.
Brush: small wash brush at 150px size.

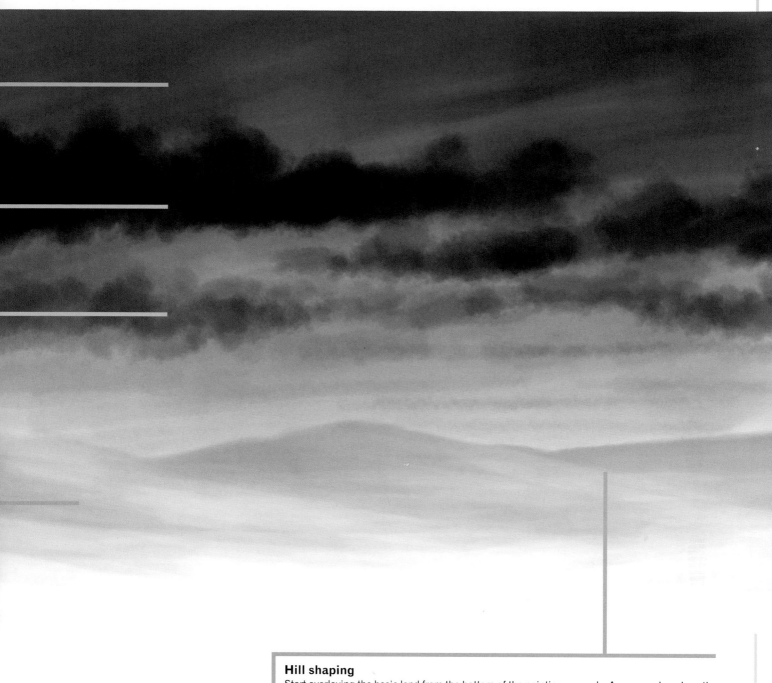

Hill shaping

Start overlaying the basic land from the bottom of the painting upwards. As you work, reduce the opacity of the colour and the size of the brush to add sweeping strokes that follow the contours to build up the shape of the hills.

Colour: snow white at full opacity, gradually reducing to fifteen per cent opacity at the crests of the hills.

Brush: small wash brush at 150px size, gradually reducing to 75px at the top.

Stage 2: Main shapes

Digital art makes water easy, as you can keep it isolated from the surroundings and adjust it later if necessary.

Because it is reflecting the colours in the sky, water in the landscape is worked like a sky, but in reverse – from bottom to top. Adding ripples helps to prevent it looking like a perfect mill pond, but these should be added after the water has been established as this will help you make those further away slightly finer and fainter to create the impression of distance.

New colours

Light brown

Dark brown

Violet

Off-black

Layers

1 **Sky background**

2 **Clouds**

3 **Land**

4 **Water**

5 **Tree**

Winter tree

See pages 50–51 for how to paint a winter tree. Keep the highlights on the left-hand side, and use off-black towards the bottom of the tree.

Colour: light brown and dark brown at full opacity, changing to fifty per cent opacity for overlaying highlights and texture.

Brush: branch brush at 25px size for the trunk and main branches, reducing to 10px for the smaller branches.

Hedgerows

Add two or three horizontal rows with circling motions, with occasional larger spirals for trees.

Colour: cloud grey at seventy-five per cent opacity.

Brush: cloud brush ranging between 15px size for midground to 4px for more distant hedgerows.

Snow shadows

Build up a horizontal band following the line of the nearest hedgerows and follow the contours of the land. Overlay the colour in recesses to add depth.

Colour: violet at twenty-five per cent opacity.

Brush: small wash brush at 25px size, with the hardness altered to 25 and intensity to 10.

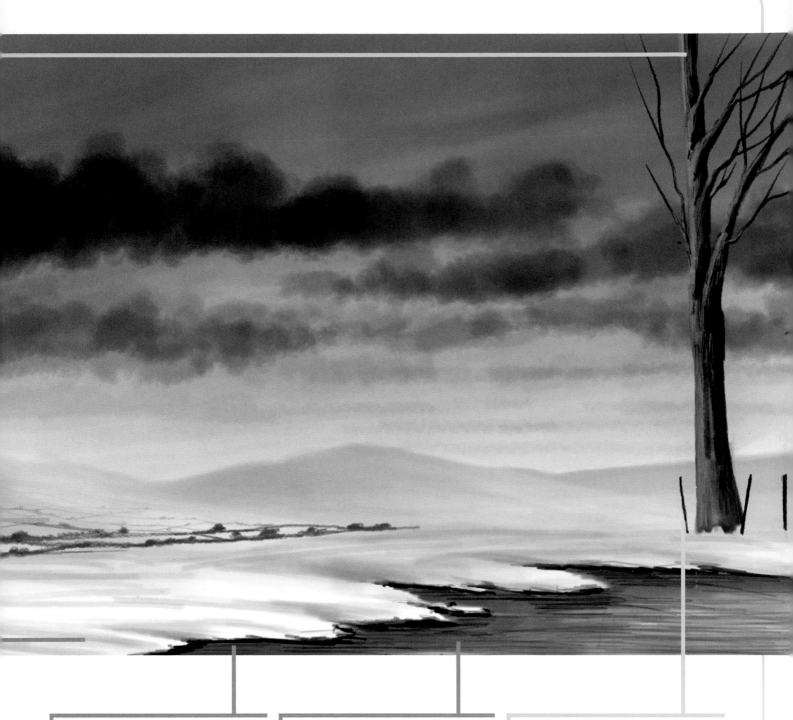

Banks and ripples

The banks are important to provide definition to the river, and the ripples are important for realism.

Colour: off-black at seventy-five per cent opacity for banks; twenty-five per cent opacity for ripples.

Brush: small wash brush at 10px size for the banks, reducing to 5px for the ripples.

Water

Water reflects the sky, so the same colours are used, but the other way round – yellow at the top, blue-grey at the bottom.

Colour: sunset yellow at ten per cent opacity, blending to twenty-five per cent near the middle. Evening blue at full opacity at the bottom of the painting.

Brush: small wash brush at 50px size.

Fence posts

These need to be dark to provide visual contrast with the tree.

Colour: off-black at full opacity.

Brush: detail brush at 4px size.

Stage 3: Foreground detail

This part of the painting adds the foreground detail that brings interest and realism to the picture. There are some subtle effects, like the tramped-down snow on the path, the misty glaze on the water, and the reflections.

Reflections can seem tricky, but just remember that they reflect things along just one plane – this means that the highlights will stay on the left-hand side.

Layers

1	**Sky background**	**5**	**Tree**
2	**Clouds**	**6**	**Reflection**
3	**Land**	**7**	**Foliage**
4	**Water**		

Sparse foliage

Follow the instructions on pages 50–51 to add this.

Colour: light brown at full opacity.

Brush: foreground foliage brush.

Fine branches

Colour: light brown at full opacity.

Brush: branch brush.

Dappled shadows

Run the brush in criss-cross fashion to suggest the shadows cast on the trunk by the branches.

Colour: off-black at ten per cent opacity.

Brush: small wash brush at 25px size.

Barbed wire

Zoom in to draw fine lines that loop round the posts using the 2px brush, then reduce the thickness and go over the lines again.

Colour: off-black at full opacity.

Brush: detail brush at 2px size, and 1px size.

Snow texture

These marks are added to the same layer as the water because they sit in the same foreground area.

Colour: violet at twenty-five per cent opacity.

Brush: texture brush at 100px.

Fine grasses

Once you have adjusted the dynamic intensity, use quick flicking strokes to leave tapering marks.

Colour: off-black at full opacity.

Brush: detail brush at 1px size with dynamic intensity reduced to –100.

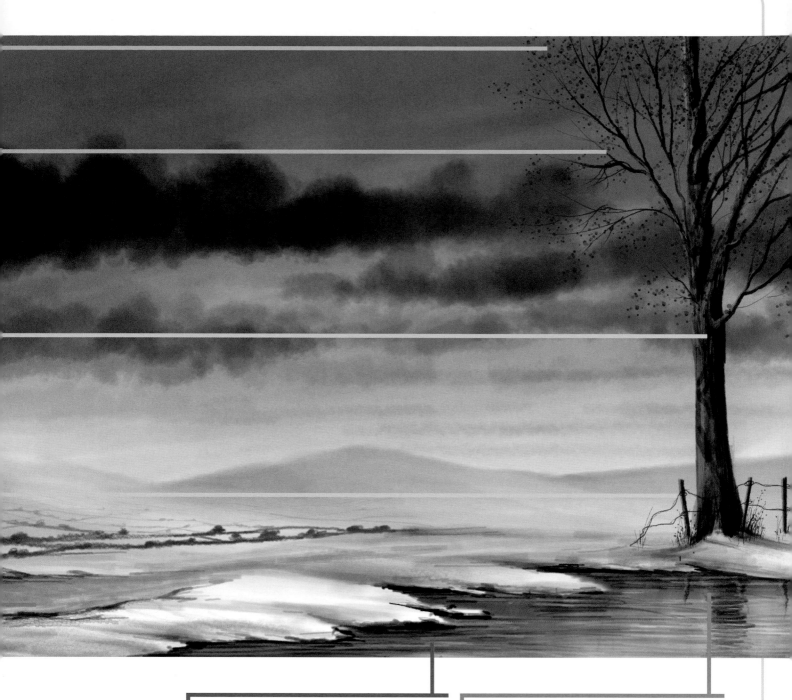

Misty glaze

A soft glaze makes the water slightly less bright than the sky, which adds realism. Concentrate it away from the banks and towards the bottom of the water area. Use mainly horizontal strokes, but add two or three downward strokes from the banks to create the illusion of depth.

Colour: snow white at five per cent opacity.

Brush: large wash brush.

Reflections

Using the same colours as the tree itself, use short horizontal strokes the width of the tree to create a broken reflection. Do the same for the fence posts after highlighting them.

Colour: light brown and dark brown at full opacity, changing to fifty per cent opacity for overlaying highlights and texture.

Brush: small wash brush at 7px, with hardness adjusted to 25.

Stage 4: Figures

Adding figures can give a landscape a sense of scale and add interest. Digital painting allows you to zoom in to paint them in detail, then shrink and move them into the correct position on the painting. They should not dominate or become the focal point.

In this painting, the figures are placed on the left to balance the strong tree on the right-hand side. Together, the figures and the tree form framing elements that makes the painting restful, peaceful and attractive to look at.

New colours

Dark skin tone

Red

Blue

Blonde

Dark blue

Layers

1 **Sky background**

2 **Clouds**

3 **Land**

4 **Water**

5 **Tree**

6 **Reflection**

7 **Foliage**

8 **Figures**

Figures

The figures are painted with the techniques described on pages 54–55, though the shape and positioning are different. Draw them larger than they will be, then use the transform controls to reduce them to scale with the path and tree.

Colour: red, blue and dark blue for the clothes; dark skin tone for skin; and blonde and dark brown for the hair (see pages 54–55 for opacities).

Brush: see pages 54–55 for brushes and sizes.

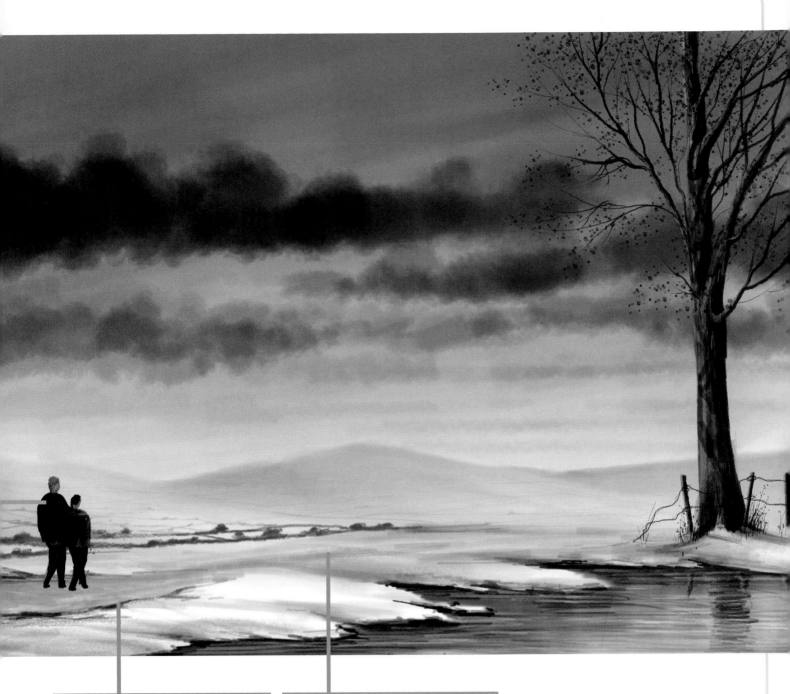

Footpath

Use horizontal brushstrokes to suggest perspective by reducing the size of the strokes as you work towards the right.

Colour: violet at twenty per cent opacity.

Brush: small wash brush with hardness adjusted to 25.

Footpath edge

Increase the strength of the colour for finer details.

Colour: dark brown at twenty-five per cent opacity, increasing to fifty per cent opacity.

Brush: texture brush at 5px size; detail brush at 5px size for details.

Stage 5: Finishing touches

Footprints and a little dog add a sense of life to the painting and ground the figures. A story is created.

Layers

The final appearance of the layers at the end of the painting.

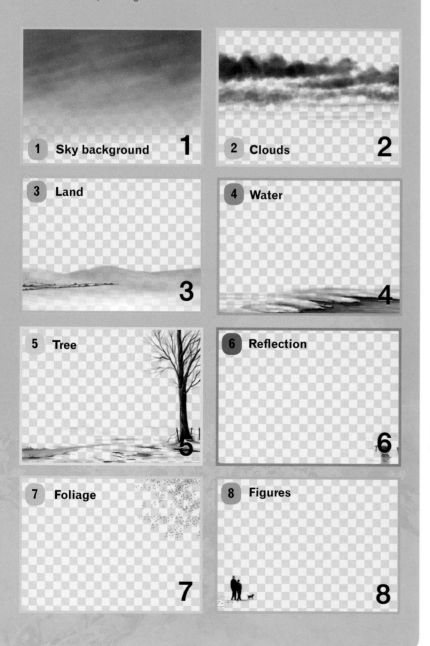

1 **Sky background** 1

2 **Clouds** 2

3 **Land** 3

4 **Water** 4

5 **Tree** 5

6 **Reflection** 6

7 **Foliage** 7

8 **Figures** 8

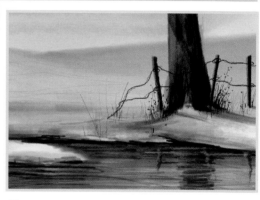

Fine grasses

Make some additional fine grasses to balance the detail on the right-hand side with the left.

Colour: off-black at full opacity.

Brush: detail brush at 1px size with dynamic intensity reduced to –100.

Footprints

Mark the footprints from the walkers larger on the left-hand side and smaller on the right as they get further away.

Colour: violet at twenty-five per cent opacity.

Brush: small wash brush at 2px size.

The finished painting

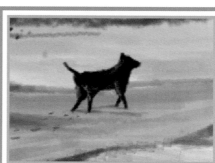

Dog

The dog is painted in much the same way as a figure, though obviously the basic shape is different, and he is simpler because he has no clothes to paint!

Colour: dark brown at full opacity, and highlights in light brown at fifty per cent opacity.

Brush: see pages 54–55 for brushes and sizes; add the final highlights with the detail brush at 1px size.

Autumn Wood

In this final painting tutorial, you will create this wonderful autumnal woodland, painting large foreground trees and a distant barn.

By this point, you will be confident enough to experiment, so enjoy yourself! This project uses ten layers in order to build up a convincing woodland canopy. However, because it is made up of multiple simple layers, it is deceptively easy to achieve. It also demonstrates how to adjust and tweak your artworks through layer transparency adjustment.

Stage 1: Background

Create two layers. Build up a basic sky as described on pages 34–37 using sky blue and blending it away to white at the bottom of the painting area.

With the sky in place, paint in the ground base, then start the canopy on the same layer as the sky. Scatter these distant leaves loosely, and paint them with a variety of different colours and brush sizes (see right).

Finally for this stage, build up the midground canopy with the same colours at a slightly higher opacity and larger versions of the same brush. This helps to blend the different layers together.

New colours

- Sky blue
- Light green
- Mustard
- Yellow
- Brown

Layers

1 **Background**

2 **Foliage**

Sky
Colour: sky blue at full opacity at the top, reducing to ten per cent at the bottom of the area.
Brush: large wash brush.

Distant canopy
The distant canopy should be dotted lightly across the upper two-thirds of the painting, with just a few touches in the centre.
Colour: light green, mustard, yellow and brown, all at twenty-five per cent opacity.
Brush: foreground foliage brush at sizes between 50px and 200px.

Midground canopy
Restrict this stronger part of the canopy to the edges of the painting.
Colour: light green, mustard, yellow and brown, all at fifty per cent opacity.
Brush: foreground foliage brush at sizes between 100px and 300px.

Ground base
Use horizontal strokes of the brush to build up the ground, starting from the bottom.
Colour: mustard at seventy-five per cent opacity at the bottom, reducing to fifteen per cent at the top of the area.
Brush: large wash brush.

Ground corners
Colour: brown at fifty per cent opacity.
Brush: large wash brush.

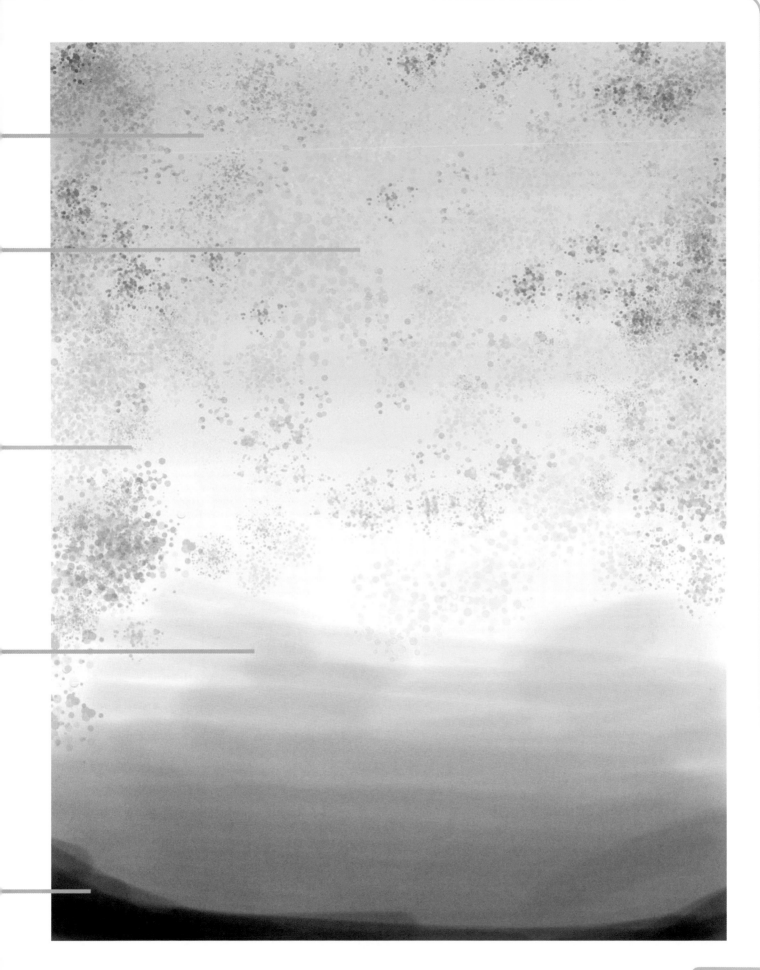

Stage 2: Softening

A new brush is introduced for this stage. The crosshatch brush allows you to deepen the tone in the upper corners (as you might for the sky) without obscuring the delicate texture of the foreground foliage brush.

The strokes in this stage are made with very large and diffuse colours and brushes. Take your time building up the tone and depth in the picture, and remember that you can undo anything. Relax and enjoy.

New colours

Rust brown

Bright green

Dark brown-grey

Layers

1 **Background**

2 **Foliage**

3 **Haze**

New brush: Crosshatch brush

Differences from the default round brush:

Size: 50px Angle: 0

Density: 10 Spacing: 10%

Deviation: 0% Jitter: 100

Intensity: 25 Scatter: 100

Sky tone

Strengthen the tone at the corners.

Colour: dark brown-grey at twenty-five per cent opacity.

Brush: large wash brush at 300px.

Canopy tone

Strengthen the tone at the edges and corners with a new brush that increases the depth and complements the texture of the leaves.

Colour: bright green and yellow at ten per cent opacity.

Brush: crosshatch brush at sizes between 50px and 200px.

Midground haze

Add a haze to the forest floor with a glaze made with smooth horizontal strokes.

Colour: bright green and yellow at ten per cent opacity.

Brush: large wash brush at 300px.

Foreground haze

Add a haze to the forest floor with a glaze made with smooth horizontal strokes.

Colour: rusty brown at twenty-five per cent opacity.

Brush: large wash brush at 300px.

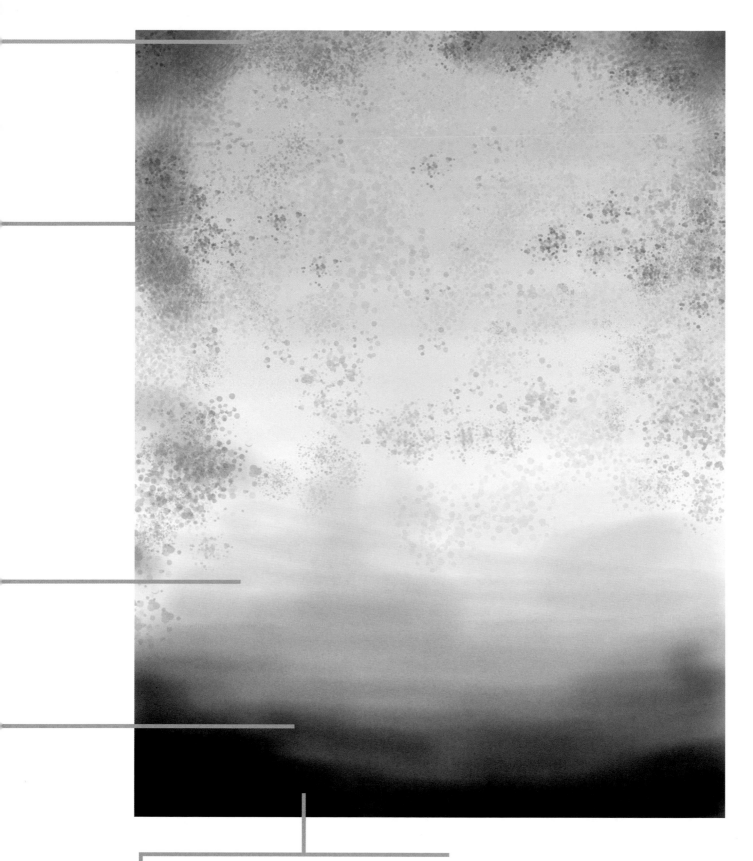

Forest floor corners
Strengthen the haze in the lower corners with an additional layer
to build up the depth.
Colour: dark brown-grey at twenty-five per cent opacity.
Brush: large wash brush at 300px.

Stage 3: Footpath and texture

With the background in place, we can now start to bring the painting forward by adding a foreground footpath. This leads the eye into the painting.

In addition, this stage sees the addition of more tone and texture in the sky. A misty impression is created across the woodland floor.

Layers

1 **Background**

2 **Foliage**

3 **Haze**

4 **Footpath**

Sky tone

Using tapping gestures to add a few tonal touches to the central area creates natural shading and depth to the sparser, more open foliage here.

Colour: dark brown-grey at ten per cent opacity.

Brush: large wash brush at 300px.

Background footpath

Extend the winding footpath from the top of the rust-brown area into the distance.

Colour: dark brown-grey at ten per cent opacity.

Brush: texture brush at 10px at bottom, reducing to 5px at the top.

Foreground footpath

Build up the footpath gradually, aiming for a loose, winding zig-zag shape that leads up from the bottom of the painting area to the top of the rust-brown area. Build up the colour in repeated layers to create the strength you need.

Colour: dark brown-grey at twenty-five per cent opacity.

Brush: cloud brush at 50px at bottom, reducing to 10px at the top as shown above.

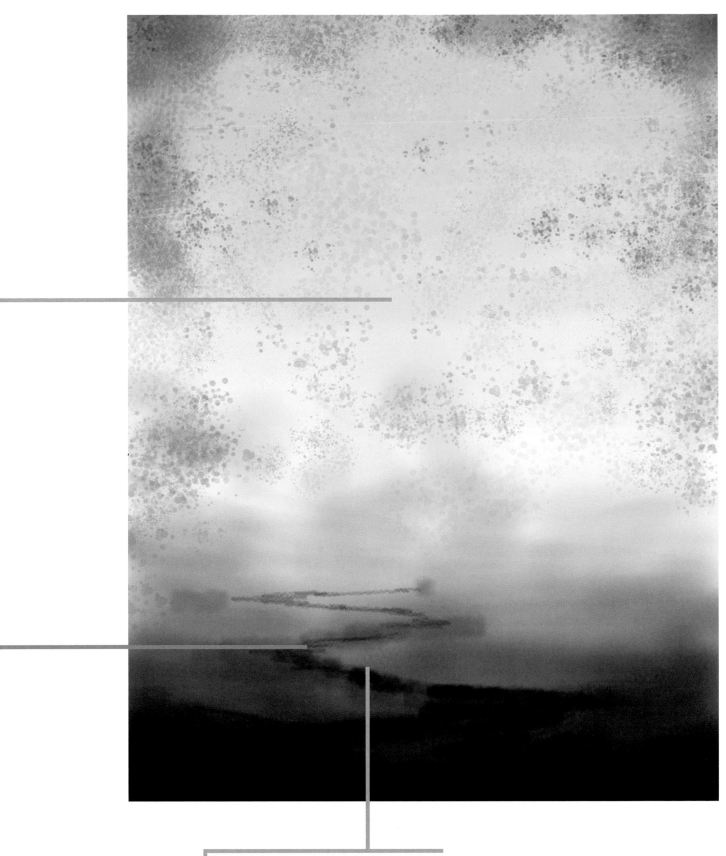

Mist
Overlay the footpath with a misty effect.
Colour: dark brown-grey at five per cent opacity.
Brush: crosshatch brush at 100px.

Stage 4: Trees and water

Painting in standing water that has filled the ruts in the path adds some brightness to the foreground, and we also add the beginnings of the trees supporting the foliage at this stage. These are restricted to the background, though the shadows of trees just out of sight cast shadows across the foreground.

New colours

■ Off-black

□ Pure white

Layers

1　**Background**

2　**Foliage**

3　**Haze**

4　**Footpath**

5　**Distant trees**

6　**Water and detail**

7　**Spotty foliage**

New brush: Spotty brush

‹ Brushes　　**Brush**　　↻

| Bristle Density | 25 |
| — | + |

| Intensity | 100 |
| — | + |

| Angle | 50 |
| — | + |

| Spacing | 75% |
| — | + |

| Jitter | 0 |
| — | + |

| Scatter | 75 |
| — | + |

| Dynamic Angle | 0 |
| — | + |

| Dynamic Weight | 0 |
| — | + |

| Dynamic Intensity | 100 |
| — | + |

Differences from the default round brush:

Size: 150px　　*Angle: 0*

Density: 10　　*Spacing: 10%*

Deviation: 0%　*Jitter: 100*

Intensity: 25　*Scatter: 100*

Canopy

To increase the mass of foliage and add variety, a new brush is used. Other than this, the technique and colours are the same as used in stage 1.

Colour: light green, mustard, yellow and brown, all at twenty-five per cent opacity.

Brush: spotty brush.

Misty trees

Make sure the base of every tree is near the horizon line. Use shorter strokes for those further away, and overlay those further forward with additional strokes, especially at the base.

Colour: rust brown at fifty per cent opacity. Add off-black at twenty-five per cent opacity on the left-hand sides of those nearer the midground.

Brush: small wash brush at 20px size at the bottom, reducing to 10px in the distance.

Shadows

Start each tree's shadow at the base of the tree, and keep the direction of all the trees consistent.

Colour: off-black at ten per cent opacity.

Brush: small wash brush at 20px size at the bottom, reducing to 10px in the distance.

Standing water

Create a puddle of standing water that reflects the colours in the sky.

Colour: pure white at fifty per cent opacity.

Brush: small wash brush at 20px size at the bottom, reducing to 10px in the distance.

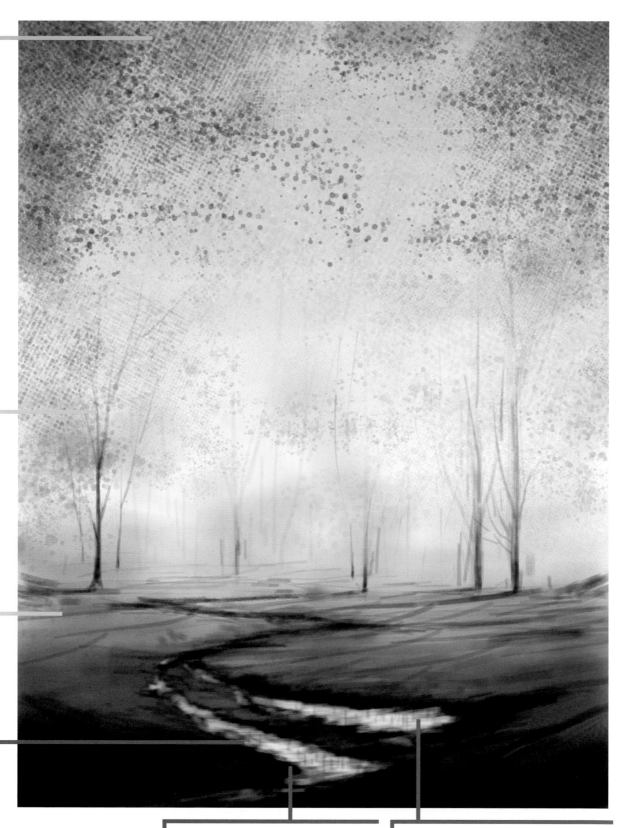

Edges of the puddle
Colour: off-black at fifty per cent opacity.
Brush: detail brush at 5px size.

Reflections
Subtlety is key. Add just a few vertical strokes to suggest reflections of the distant trees.
Colour: off-black at ten per cent opacity.
Brush: detail brush at 5px size.

Stage 5: Main tree

Adding a large foreground tree creates a strong focal point in the foreground, which pushes back the distant trees and results in wonderful depth across the painting.

With this in place, the foreground scale is set, and some small fenceposts can be added. These will be developed in the next stage, and the resulting foreground detail at the bottom will ensure that the tree does not become too dominant.

New colours

▢ Fawn

Layers

1 **Background**

2 **Foliage**

3 **Haze**

4 **Footpath**

5 **Distant trees**

6 **Water and detail**

7 **Spotty foliage**

8 **Foreground foliage**

9 **Main tree**

Foreground foliage

Larger, stronger marks are built up to help give an autumnal feel.

Colour: rust brown at seventy-five per cent opacity.

Brush: foreground foliage brush at 350px size.

Tree trunk

Follow the steps on pages 50–51 to create the trunk of a tree (see left), keeping the highlights on the right-hand side of the trunk.

Colour: dark brown-grey at full opacity, and rust brown at fifty per cent opacity for the highlights.

Brush: branch brush at 25px size, reduced to 10px for the highlights.

Fenceposts

Colour: dark brown-grey at full opacity, and rust brown at fifty per cent opacity for the highlights.

Brush: detail brush at 5px size.

Fallen leaves

Add small amounts of fallen leaves with tapping motions.

Colour: rust brown at seventy-five per cent opacity.

Brush: foreground foliage brush.

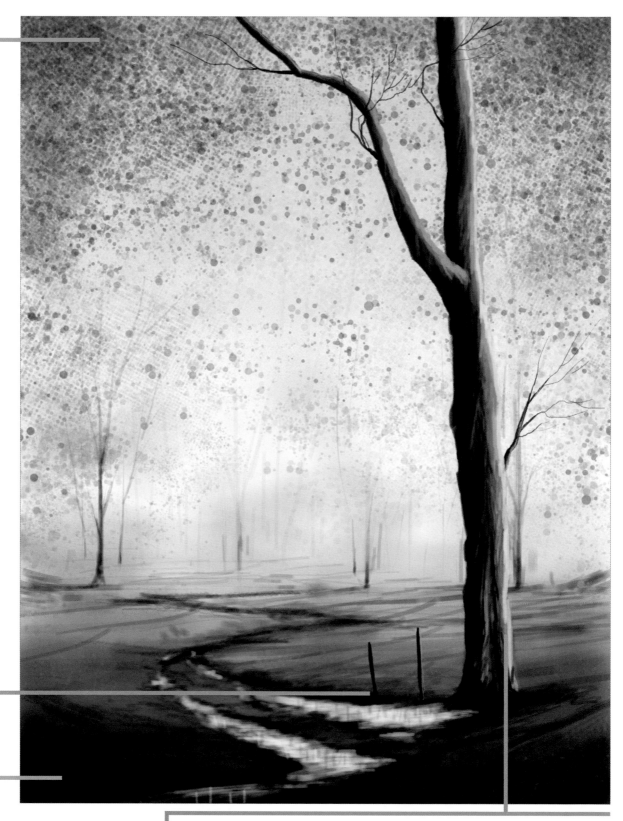

Tree detail

Add branches to the trunk as described on pages 50–51, and add stronger detail and highlights on the right-hand sides as shown.

Colour: branches as for the tree (see 'Tree trunk', opposite), fawn at fifty per cent opacity for the extreme highlights.

Brush: branch brush at 25px size, reduced to 10px for finer branches. Add the highlights with detail brush at 5px size.

Stage 6: Refining the composition

No new layers or colours are added at this stage. Instead, we concentrate on refining the areas already present and ensuring that the main shapes work well before continuing.

In particular, the foreground is developed, with the main tree being integrated into the composition more with an additional large branch into the centre, and more detail being built up at the base.

Layers

1 **Background**

2 **Foliage**

3 **Haze**

4 **Footpath**

5 **Distant trees**

6 **Water and detail**

7 **Spotty foliage**

8 **Foreground foliage**

9 **Main tree**

Large branch

This additional branch helps to structurevwwv the picture and keeps the interest near the centre. Note how it echoes the shape of the path below.

Colour: dark brown-grey at full opacity.

Brush: branch brush at 25px size.

Additional fence posts

These are painted in the same way as those in the previous stage. Note that since they sit in front of the water, they have no visible reflections.

Colour: dark brown-grey at full opacity, and rust brown at fifty per cent opacity for the highlights.

Brush: detail brush at 5px size.

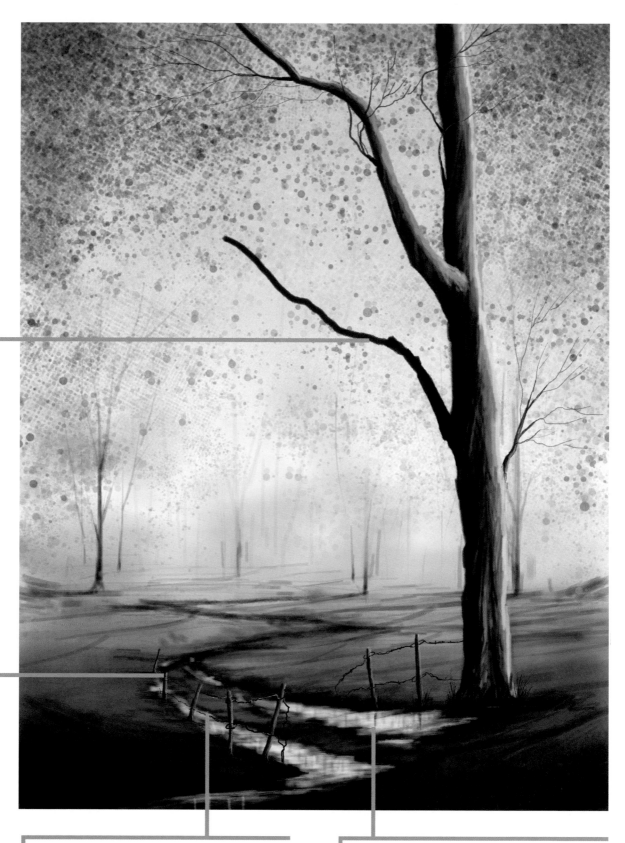

Barbed wire

Zoom in to draw fine lines that loop round the posts using the 2px brush, then reduce the thickness and go over the lines again.

Colour: off-black at full opacity.

Brush: detail brush at 2px size, and 1px size.

Reflections

Add a few vertical strokes for the reflection of the fence posts. Make them a little stronger than those of the distant trees (see stage 4).

Colour: off-black at ten per cent opacity.

Brush: detail brush at 5px size.

Stage 6: The barn

The barn adds an important focal point to the painting. The path leads towards it, and it is framed by the midground trees. To enhance the effect and draw the eye, it is painted with warm, inviting colours.

New colours

 Warm fawn

 Autumn red

Layers

1 **Background**

2 **Foliage**

3 **Haze**

4 **Footpath**

5 **Distant trees**

6 **Water and detail**

7 **Spotty foliage**

8 **Foreground foliage**

9 **Main tree**

10 **Barn**

Foreground foliage

Use the brush at its maximum size to add the largest spots and dots possible. Tap on touches around the edges.

Colour: light green, mustard, yellow, brown, and autumn red, all at seventy-five per cent opacity.

Brush: foreground foliage brush at 512px.

Additional fine branches

Colour: dark brown-grey at full opacity.

Brush: branch brush.

Barn walls

Build up the shape following the instructions on pages 56–57.

Colour: off-black, warm fawn.

Brush: detail brush.

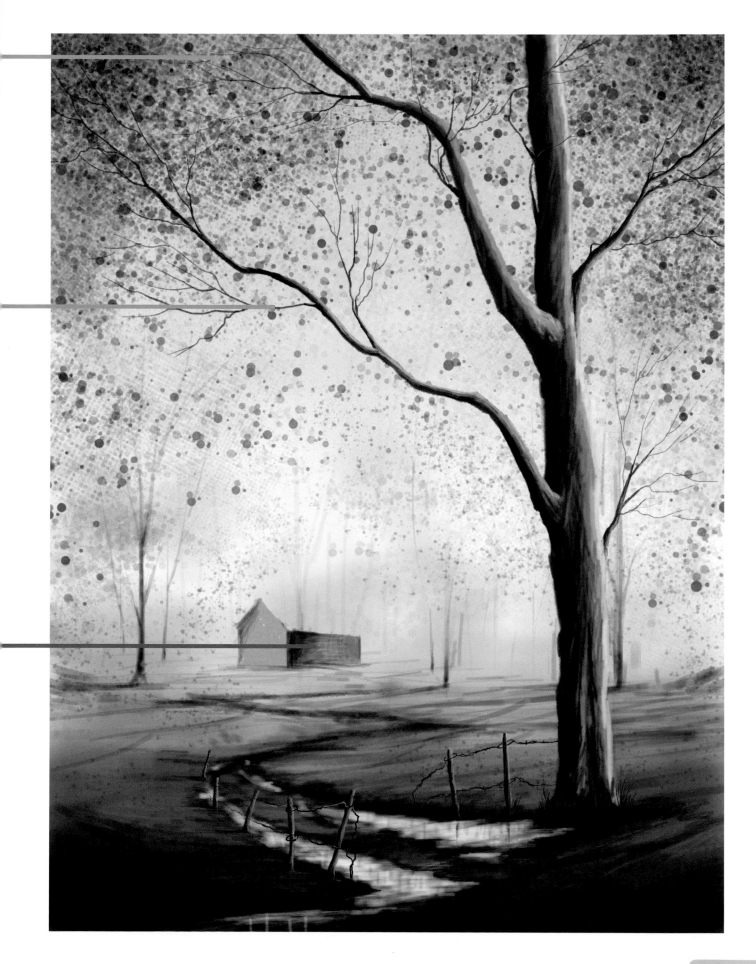

Stage 7: Finishing touches

The barn adds an important focal point to the painting. The path leads towards it, and it is framed by the midground trees. To enhance the effect and draw the eye, it is painted with warm, inviting colours and some finer detail is added.

Once I had completed the barn, I decided to experiment with size and placement, using the transform control to turn it around. Feel free to experiment like this and play as you paint. The advantage of having so many layers is that you can adjust, alter or replace elements without risking other parts.

An important change was to reduce the transparency of the whole layer, which has the effect of making the colours and lines softer. This gives the impression that the barn is in the middle distance, which prevents it from being too strident in the overall picture.

New colours

 Terracotta

Layers

1	Background	6	Water and detail
2	Foliage	7	Spotty foliage
3	Haze	8	Foreground foliage
4	Footpath	9	Main tree
5	Distant trees	10	Barn

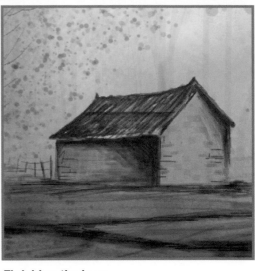

Finishing the barn
Complete the barn with roofing detail and a small fence worked in off-black, then glaze the roof. Once complete, reduce the transparency of the whole layer to seventy-five per cent; and use the transform controls to flip it horizontally. Drag it back into position if it moves.

Colour: off-black, terracotta.

Brush: detail brush.

Foliage
As earlier, use the brush at its maximum size to add the suggestion of leaves around the upper half of the painting. These are on the same layer as the barn, so they will be fainter than the earlier versions owing to the layer transparency being altered (see above).

Colour: light green, mustard, yellow, brown and autumn red, all at seventy-five per cent opacity.

Brush: foreground foliage brush at 512px.

The finished painting.

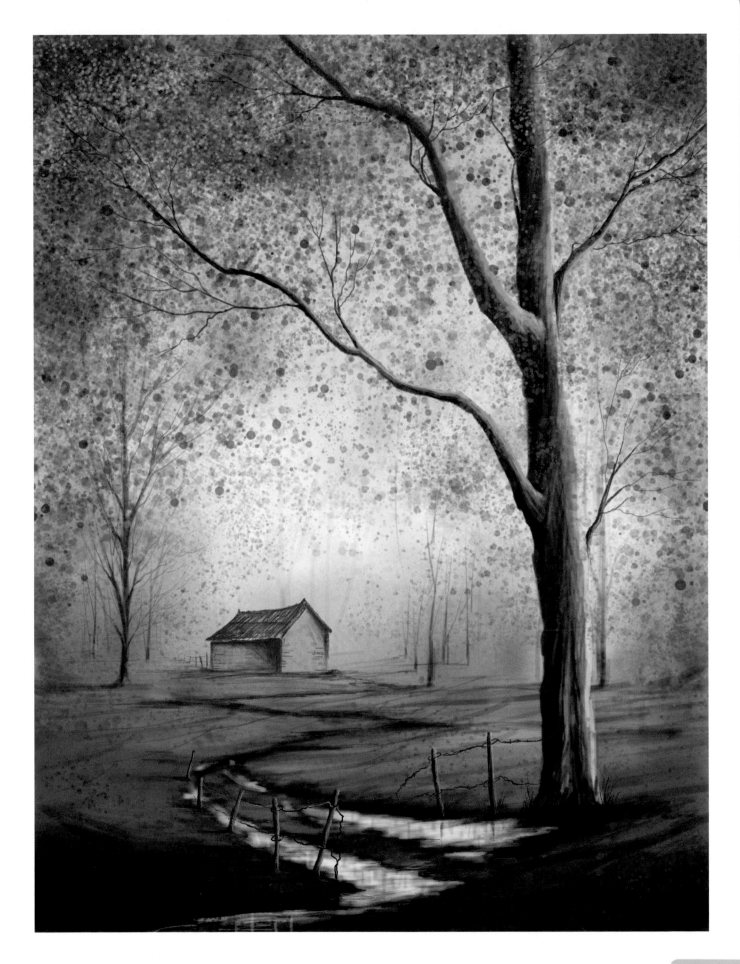

What next?

Having worked through the exercises and projects earlier, you will now have built up enough experience to confidently begin painting your own landscapes. Alternatively, you might want to go back to your paintings and alter or improve them – perhaps by adding objects or changing sections.

In either case, I want to reiterate how useful layers can be to your painting. These pages show all of the layers used in the final project, *Autumn Wood*, along with the transparency bars. This illustrates how you can spread dense textures (such as the leaves) across multiple layers to achieve a more convincing effect. In addition, by spreading them out like this, changes you make to one layer will not completely alter the effect in the others – a useful time-saver.

Experiment with your paintings, and remember to use your layers!

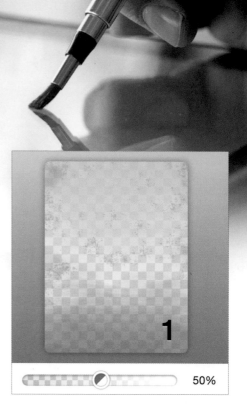

1 50%

2 100%

3 100%

4 100%

5 100%

6 100%

7 100%

8

100%

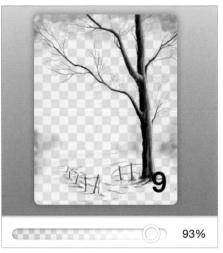

9

93%

10

78%

The finished painting.

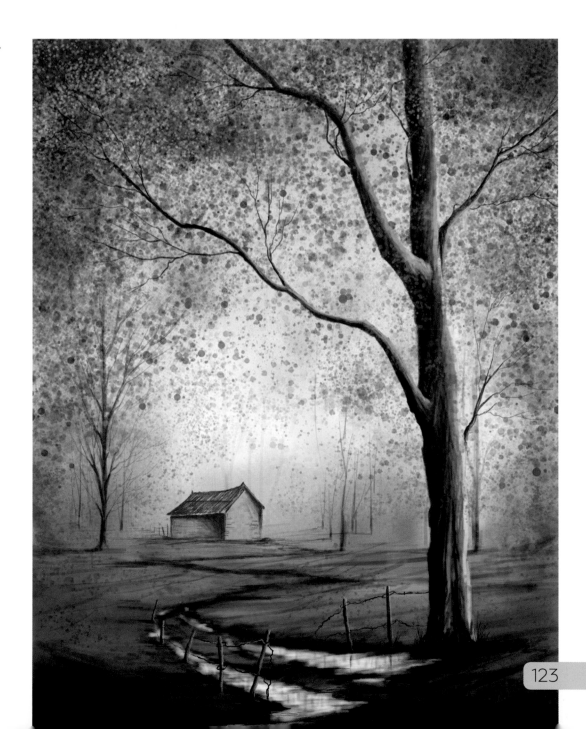

More unusual landscapes

Landscapes are not restricted to green fields or hills. They include coastal pictures, dramatic mountains and city scenes like the one shown here.

When looking for inspiration, use the camera on your tablet. Whether I have my tablet or smartphone with me, I always carry a camera and keep an eye out for unusual or interesting landscapes. There is quite simply a painting in every scene.

Be adventurous and try something different – and don't be afraid to use artistic licence if it gives you a better result.

Palmer's Bar, New York City

This painting was inspired by a recent trip to New York. The combination of the bright lights and strong lines of the skyscrapers is very evocative, and so I used the photograph below to provide the colours and inspiration for the finished painting opposite.

The painting was built up in stages, which can be seen to the left. Starting with a moody sky and the midground skyscrapers, I then added the background buildings before developing the foreground. I couldn't resist adding my own twist to the signage, and decided to give myself a little bar of my own in the Big Apple – welcome to Palmer's Bar!

The source photograph.

Opposite:
The finished painting.

124

Making it real

So, you have finished your masterpiece – what now? How do you share them with your friends and family? With tablet art, the world is your oyster. You only have to paint a picture once, and you then have endless copies to share. You can send your paintings via email, post them on social media or print them; essentially turning them into traditional paintings that you can frame and display.

Some art apps, like *Brushes* and *Procreate*, allow you to export the entire painting as a video. These apps record every brushstroke you make – handy for showing how you achieved a certain result, and fun and fascinating to watch.

Sharing

Brushes

Once your artwork is complete, simply tap the share icon in the upper right-hand corner of your screen. You are then presented with the options shown to the left. I tend to simply use the 'add to photos' option. This saves the finished painting to your tablet's camera roll. You can then print or share your finished painting in exactly the same way as any other picture.

Procreate

Procreate is an app aimed more at professional art workers, and gives you more format options for saving than *Brushes*. Unless you have a specific purpose in mind that requires a different format, it is sensible to keep things simple and save the image in the 'JPG' file format.

1 Tap the 'spanner' icon and then share. Here you can export the finished painting, and save to your iPad's photos, or camera roll.

2 Select JPG format.

3 The image is now saved and can be shared via text message, email or a number of other ways shown above.

Printing

Printing your digital artwork is easy – assuming you have a printer, of course! Once you have saved your painting to your tablet's photo library, you can print directly from your tablet if tablet printing is supported. If not, try sending the painting to your computer via email. You can then print it exactly as for any other picture or photograph.

If you do not feel confident printing yourself, or you want a high-quality surface that your printer can not support, there are many companies that will print your digital artwork on a canvas for a great-looking result. Simply use an internet search engine to look up 'printing photographs on canvas' or similar.

> ### Tip
>
> If your printer can take the paper weight, try printing on 190gsm (90lb) watercolour paper for a fantastic result. If not, a good semi-gloss photographic paper is ideal for digital paintings.

Exporting as a video

Common art apps like *Brushes* and *Procreate* allow this export. With *Procreate* you can even upload the result to a video sharing site.

This is really just a bit of fun, but it is also useful to watch how you painted that favourite scene. It is worth noting that these videos play back at a high speed, not in realtime. Have a go: share your creation with the world!

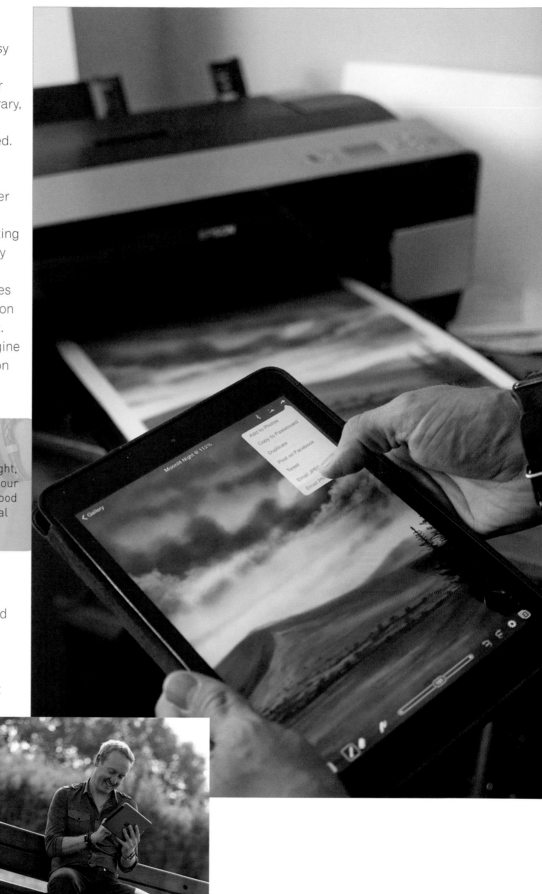

Index